SCOTLAND REMEMBERED

A History of Scotland Through Its
Monuments and Memorials

Michael Meighan

AMBERLEY

For Luca: plenty more history to come

First published 2019

Amberley Publishing
The Hill, Stroud
Gloucestershire, GL5 4EP

www.amberley-books.com

Copyright © Michael Meighan, 2019

The right of Michael Meighan to be identified as the
Author of this work has been asserted in accordance
with the Copyrights, Designs and Patents Act 1988.

ISBN 978 1 4456 9650 8 (print)
ISBN 978 1 4456 9651 5 (ebook)

British Library Cataloguing in Publication Data.
A catalogue record for this book is available from the
British Library.

Typesetting by Aura Technology and Software
Services, India. Printed in Great Britain.

Contents

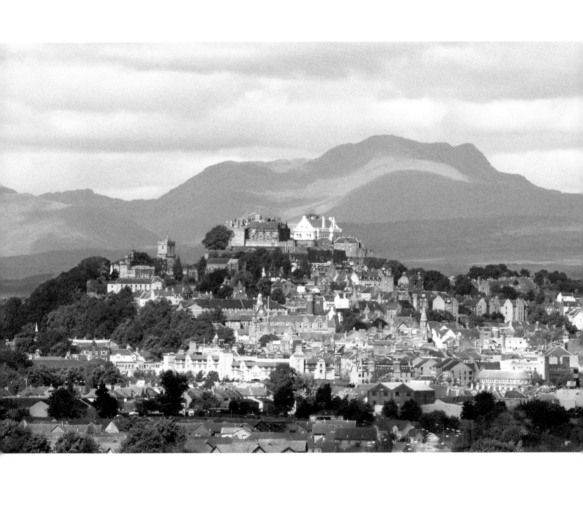

Introduction

We walk or drive past memorials and monuments every day of the week but very often we are only vaguely aware of their existence. They are in cemeteries or in parks. They are there on busy streets and squares. They stand by the sea or on the top of lonely hills.

They commemorate many things but most of all the great moments in history, as well as the dead in wars at home and abroad. They commemorate disasters, both recent and long past. They also honour the achievements of our inventors, our writers and explorers and of our kings, queens, saints and martyrs. Sometimes, as in Edinburgh, they remember famous animals such as Greyfriars Bobby.

They appear as statues, as windows, as sculptures, as plaques and sometimes as buildings. Sometimes they take centre stage in the middle of our great city squares or we may have to climb to find them at the summits of solitary mountains.

As I carried out research for previous books I marvelled at the stories behind the creation of some of these monuments; the skill and care that went into the sculpting of the granite war memorials, gravestones or tablets. And of course, many of the memorials are buildings.

Some of the monuments were installed long after the events that they commemorate, so are listed in order of the date that they represent. The last chapters contain a representative selection of some of our great scientists, explorers, writers, builders and other events. My apologies if I have missed your favourites.

So please take a journey with me and if you can visit some of the places where the monuments stand, then, like me, you will be enthralled by Scotland's history.

1. Ancient Places

Callanish Standing Stones, Lewis, Outer Hebrides

The Callanish Standing Stones stand on the edge of Great Britain where beyond is the sea and the Americas. They lie on the west coast of Lewis on the Outer Hebrides and nobody knows their origin. They may have been a court of law, a fertility temple, a theatre or part of an astronomical system. Whether they were for religious, cultural, legal or for some other reason we don't know. We can only guess. What we do know is that they represent the very beginnings of the occupation and expansion of Scotland.

For whatever purpose they were erected, they were certainly later ignored as cultivation began around them in the late Neolithic period (around 4800 BC) and many of the stones were eventually covered in peat bog. If they were once lost to the wider world, they were then probably rediscovered by a Victorian Britain fascinated with tales and images of the romantic past.

They are set on the rugged but lovely west coast of the Isle of Lewis surrounded on three sides by shielings, the traditional 'blackhouses', abandoned for the new buildings

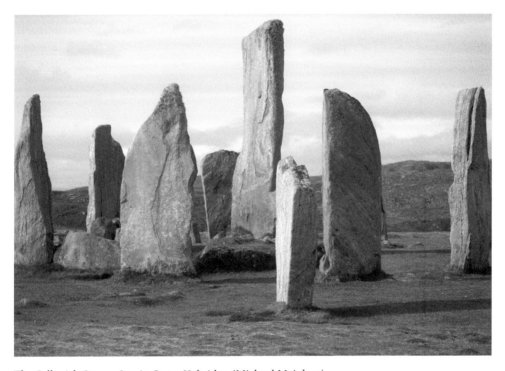

The Callanish Stones, Lewis, Outer Hebrides. (Michael Meighan)

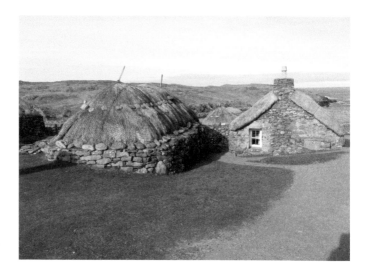

Gearrannan Blackhouse Village.
(Michael Meighan)

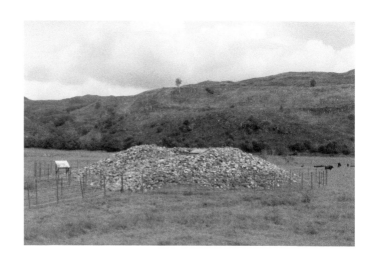

Bronze Age burial cairn
in Kilmartin Glen.
(Michael Meighan)

of the crofting communities on the islands. The complex comprises a circle of thirteen stones with a monolith in the centre. Around the circle are rows of stones, two rows of which form a corridor towards the north-east.

There is now a fine visitor centre sensitively moulded to the geography. If you visit Callanish then very near are the restored blackhouses of Gearrannan, where you can stay in the bunkhouse, and whose little museum gives some flavour of how the islanders lived for centuries.

There are, of course, other stone circles in Great Britain, most famously at Stonehenge, where 'new age' diviners and druids meet at the summer solstice to greet the rising sun. There are also several others in Scotland, although not so complete, at the Ring of Brodgar, on Orkney, Kilmartin Glen in Argyll and on Machrie Moor on Arran.

Kilmartin Glen in Argyll hosts an internationally famous archaeological landscape. There are 800 monuments including a line of five burial cairns.

The Romans in Scotland: AD 43–c. AD 410

In AD 43 the Romans invaded Britain and gradually made their way north, pacifying tribes, and by AD 79 Governor Agricola was ready to have a look at Scotland, first sending boats round the coast to discover that it was actually surrounded by water. He invaded and had conquered the south by AD 83, but met huge armed resistance from the tribes of what the Romans called Caledonii.

The Bridgeness Slab central panel translates from Latin as 'For the Emperor Caesar Titus Aelius Hadrianus Antoninus Augustus Pius, Father of his country, the Second Augustan Legion completed (the wall) over a distance of 4652 paces'. (Michael Meighan)

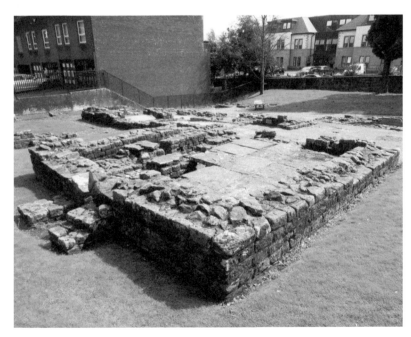

Bearsden Roman Bathhouse on the Antonine Wall. (Michael Meighan)

Agricola was rather put out by all of this and sent his troops north to confront these local tribes. The Caledonians however were apt to avoid confrontation. This only proved workable until the Romans approached the grain stores where the winter's foodstuffs were stored. This meant fight or die, so the Caledonians fought. In AD 84 they mustered 30,000 warriors to meet the Romans at Mons Graupius, of uncertain location, but possibly near Stonehaven. This was a huge encounter. The Roman army was half as big again. The warriors held the higher ground but they did not have the discipline well known of the Roman legions.

The Caledonii followed their leader, a man called Calgacus ('possessing a blade'). In fearful hand-to-hand combat the Caledonians were gaining the upper hand, almost outflanking the Romans. The Roman cavalry overcame this tactic by hiding their cavalry, who then bore down on the warriors who then broke and fled. The death toll was awful, as were the reprisals. While they fought ferociously till the end it is claimed that 10,000 Caledonians were killed and the rest fled, being pursued by the Romans.

To the Caledonians, it must have seemed like half-time because the pursuit stopped just as winter was approaching. Then, for possibly political reasons, Emperor Domitian recalled Agricola to Rome in AD 85, where he went into retirement and died in AD 93.

From AD 122 Emperor Hadrian built his wall from the Solway to the Tyne, marking the frontier of the Roman Empire. His successor, Antoninus Pius, extended the frontier further north and built the Antonine Wall from the Forth to the Clyde. The use of the wall as a barrier lasted only around twenty years until it was abandoned in AD 144.

In 1868, a distance slab created by the Romans around AD 142 was found at Bridgeness in Bo'ness. While the original is in the National Museum of Scotland, a replica is now in Kinnigars Park. This is the most complete and detailed of a small number of distance slabs found on the route of the Antonine Wall. If you visit the marvellous Hunterian Museum at Glasgow University you can see others.

Antoninus was unable to conquer the Caledonian tribes and when he was succeeded by Marcus Aurelius, Hadrian's Wall again became the northern frontier.

We are left with very little of Antonine's Wall. Along the 37-mile stretch there would have been a manned fort every couple of miles. There was one of these in Bearsden, which was uncovered in 1973. The best example of a bathhouse found in Scotland was uncovered here and is looked after by Historic Scotland.

By the late fourth century Rome was losing its grip. Political strife, military coups, invasions and decline were bringing about its fall. By AD 383 they were gone from the north and by 410 they had exited Britain, leaving the way open for new kingdoms and new conflicts in the tribal Scotland that they had never really pacified.

The Picts

By the time of the fifth century, in the early medieval period, Scotland was made up of confederations of tribes. North-east of the Forth-Clyde divide was a rough grouping called Picts by the Romans. Part of the general grouping called Caledonii, the Picts had what was possibly their largest power base at Burghead, Moray, a coastal town from which they could maintain power and trade.

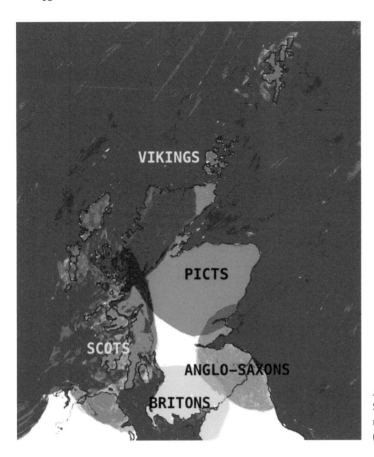

A rough guide to where Scotland's early people made their homes. (Michael Meighan)

Much of the early history of Scotland is conjecture and myth and there is actually very little known about the Picts. Of course, the Picts didn't call themselves that. The name seems to have been given by the Romans and means 'painted people'. We do know a little about them through the distribution of Pictish stones and place names. These stones date from the period during which the Picts were introduced to Christianity. Some of the best-preserved examples of Pictish stones are in the Angus hamlet of Aberlemno. The stones are covered during the winter to protect them, but there is a replica of one of the largest on show.

Another place associated with the Picts is the nearby Meigle Sculptured Stone Museum. Here you can see twenty-seven stones set in a Victorian schoolroom. Meigle was an ecclesiastical and political centre as a well as a burial place of nobles. It is thought that this place is associated with the legend of King Arthur, and particularly his queen, Guinevere, known locally as Vanora, who is said to be buried here after she died when passing through. A beautiful monument known as Queen Vanora's Stone was once within the attached churchyard beside a mound known as Vanora's Mound. The stone is now in the museum.

Early Picts have been described as raiding along the coast during Roman times but were also traders. They existed in small communities and were known to have built stone brochs, a kind of double-walled stone structure that may have been used for

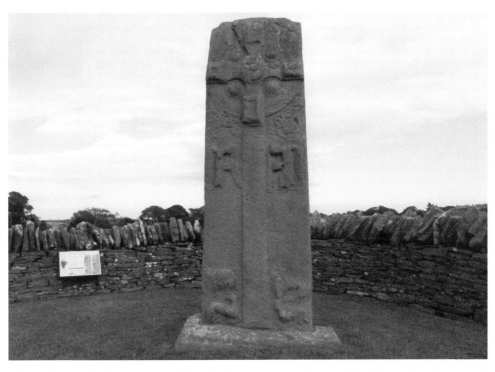

Above: The Roadside Cross, one of the Aberlemno stones, has stood in this position for around 1,200 years. (Michael Meighan Collection)

Below: Bostadh Iron Age House. (Michael Meighan)

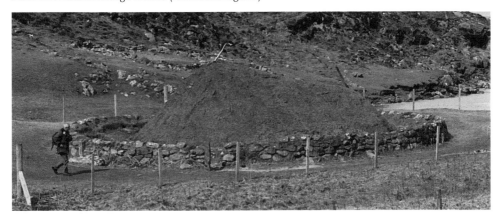

storage, security and, or, for homes for tribal leaders. They are more associated with the roundhouse, a circular building with a conical roof. A particular type of roundhouse is the crannog, a roundhouse built on an artificial island.

At Bostadh in the Outer Hebrides is a reconstruction of a roundhouse slightly higher than where a number were excavated in 1996 when they were exposed by a winter storm in 1993. They were thought to have been occupied between the sixth and ninth centuries.

The Scots

The Name 'Scotii' was given by the Romans to tribes or peoples within that larger grouping that they called Caledonii and it was once thought that these Scots were mostly of Irish descent. While there were growing contacts with Ireland through the spread of Christianity, there is no great evidence that there were large movements. The fact that Gaelic was a common language is put down to gradual population movement and intermarriage within the indigenous peoples and perhaps some minor power grabs. In fact, the west of Scotland was sparsely populated, so the coming of the Irish had no great immediate effect. It does appear certain that royalty from Ireland did make their home here.

This kingdom of the Gaelic-speaking Scots was called Dal Riata and their centre of power was their fortress at Dunadd in Argyle and Bute, which they occupied from the 500s to the 800s. The kingdom included a small part of Antrim in Ireland, Lorne, Cowal and Kintyre as well as the islands of Islay and Iona.

Their growing power inevitably brought them into occasional conflict with the Picts with whom they could also live alongside fairly comfortably. They also joined forces to resist the advances of Romans and then the Angles and Vikings. They eventually merged in the face of threats from Scandinavia and from Northumbrian Angles. That merger took place under the kingship of Pictish king Kenneth McAlpin. The new kingdom was to become known as Alba.

Dunadd plays an enormously significant part in Scottish history and on the fort you can walk on the footsteps of kings, for at the top of the rock there is a carved footprint said to be where kings would be inaugurated when they placed one foot in it. Legend has it that the folk hero Ossian gouged the hole with his foot when he leaped onto the rock from Rhudle Hill, 1 km away.

Dunadd Fort sits above the 'Great Moss' Moine Mhor in Kilmartin Glen.

The Britons (or Celtic Britons)

The Britons were Celtic people who occupied those parts of Great Britain to the south of lands occupied by the Picts and the Scots. In particular they were found in what we now call Strathclyde and some areas of central Scotland. Their power centre was what is now known as Dumbarton Rock, then Alt Clut.

With the northward movement of Anglo-Saxons from Northumbria, Scots, Britons and Picts came under pressure. The Northumbrians seized Edinburgh from the Britons and then pushed north into the Kingdom of the Picts, under King Bridei III. However, the King of the Angles, Ecgfrith, was stopped in his tracks in a surprise attack in the Battle of Dun Nechtain, in Badenoch.

Dun Nechtain was as important in forming the Scottish nation as Bannockburn for, had the Picts lost, then Scotland may have been lost as an independent nation. For several hundred years Scotland, as far as the Forth, had actually been part of Northumbria and the continuing push north may have turned us into Anglo-Saxons.

With the threat from the south relieved, there was a gradual unification of tribes under the title 'Scots'. Kenneth MacAlpin, Kenneth I, a king of the Picts, is also known as the first King of Scots as it was under him, in 843, that the country achieved an almost unified nation state known as 'Alba'.

Dumbarton Castle is a Scheduled Ancient Monument looked after by Historic Environment Scotland. It is well worth a climb to the top to see magnificent views of the River Clyde and beyond.

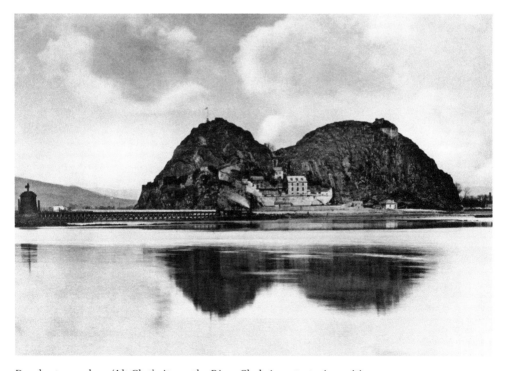

Dumbarton rock, or 'Alt Clut', sits on the River Clyde in a strategic position.

2. From St Columba to the Jacobites

St Columba, Iona and the Graveyard of Kings, AD 563

Part of the kingdom of Dal Riata was Iona, west of the Island of Mull, and on Iona is Iona Abbey, one of the earliest religious centres in Western Europe and the heart of both political and religious activity for centuries. It is where St Columba founded his monastery in 563.

Missionaries were sent forth to preach and convert throughout Scotland. They founded monasteries and priories as they went, including the priory at Lindisfarne. Eventually the old ideologies and observances of the natives were replaced by Christianity. One myth is that St Columba converted the king of the Picts, Bridei I (also known as Brude), to Christianity around 565. Bridei was king from 554 to 584 and that time the centre of the empire was at Craig Phadrig in what is now Inverness.

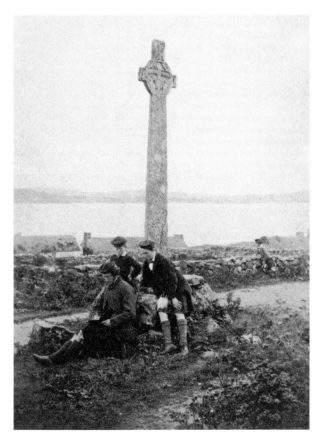

On Iona, a fifteenth-century cross thought to have been commissioned by the chieftain of Clan MacLean. (Michael Meighan Collection)

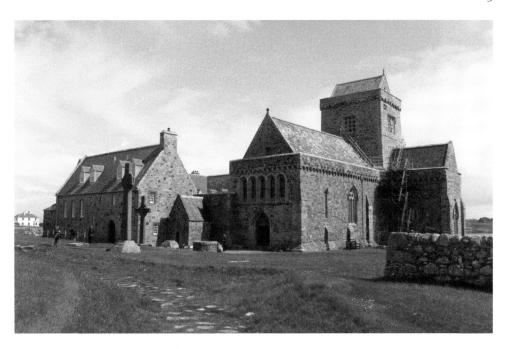

Above: The Abbey, Iona and
St Martin's Cross, dating from *c.* AD
800. (Michael Meighan)

Right: St Columba arrives at Craig
Phadrig to convert King Brude.
(Michael Meighan Collection)

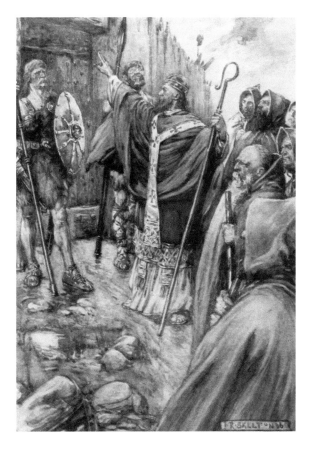

Iona did not escape the excesses of the mob during the Protestant Reformation for, of the vast number of stone crosses carved in the eighth century, more than 200 were broken and thrown into the sea.

Iona had been part of Dal Riata, and many early kings of Alba claimed their ancestry back to Iona and wished to be buried there. The number of kings is quite amazing and included eight Norwegian, four Irish and forty-eight Scottish kings including Kenneth I, Duncan I and Macbeth! It is to Iona that we turn for the largest collection of Celtic sculptures but there are others.

Another important religious centre was Brechin where a medieval cathedral was built in the thirteenth century. The building features eleventh-century stone sculptures but it is of enormous importance because of its ancient round tower, only one of two in Scotland.

Round (or bell) towers were common in Ireland as pilgrims brought the idea from the Continent. As Christianity developed in Scotland the idea was brought here too. The tower escaped demolition and was built into the fabric of the building.

The other tower is in Abernethy but you will also find a more modern version of these, which was built as a memorial to the Battle of Largs. That was built in 1912.

Brechin is a must for the lover of Scottish history and while you are there you should visit the Caledonian, Brechin's heritage railway.

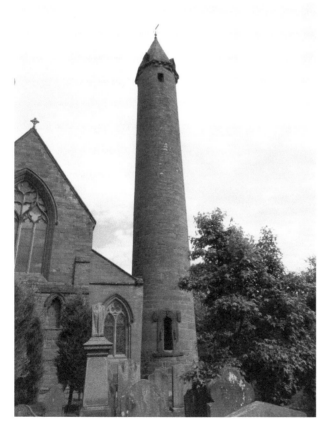

Brechin Round Tower is a Scheduled Monument attached to the medieval cathedral. (Michael Meighan)

Saint Margaret of Scotland, 1045–93

When you visit Edinburgh Castle, as you must, then at the very top of the rock you will come across a tiny building. While it is small it is celebrated as Edinburgh's oldest building and Scotland's first Romanesque building. More importantly, it is a monument chapel, built by King David I in memory of his mother, Margaret of Scotland. David reigned from 1124 to 1153.

If asked, many people in Scotland, and beyond, would say that Bonnie Prince Charlie and the '45' was Scotland's most romantic period. While it was certainly romantic, or has become so, the romance of that period tends to overshadow other eras in Scotland's history, and ones that were probably more important and whose effects were more long-lasting. Among these is the story of Saint Margaret of Scotland and her husband, Malcolm III 'Canmore' who reigned from 1058 to 1093, almost 700 years before the 1745 rebellion of Bonnie Prince Charlie.

Malcolm, who had had a relatively long reign of around thirty-five years until his death in 1093 at the Battle of Alnwick, had stolen his kingdom from Lulach 'the Fool', a weak king whom Malcolm assassinated.

You might be more familiar with Malcolm in his fictional role in Shakespeare's *Macbeth*, for it was the same (adapted for the stage) Malcolm who slew the real King Macbeth, who reigned from 1040 to 1057 and who was succeeded by Lulach.

Malcolm's first wife was reported in the *Orkneyinga Saga* to be Ingibiorg Finnsdottir, who was a widow of the Earl of Orkney, Thorfinn Sigurdsson. Ingibiorg is assumed to have died around 1069 as Malcolm then married Margaret of Wessex.

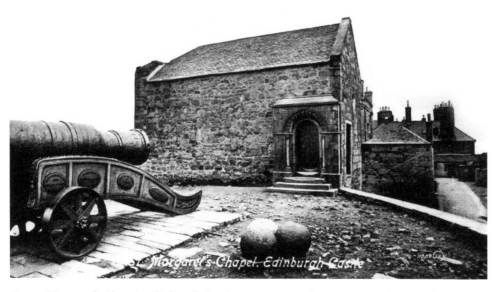

Queen Margaret's Chapel, Edinburgh Castle, was once used as a gunpowder store but is now reclaimed as a lovely chapel. (Michael Meighan Collection)

Margaret was the daughter of Edward Aetheling of the House of Wessex. Edward was the eldest son of Edmund II, 'Ironside', who was briefly King of England in 1016 followed by King Canute – 'Cnut the Great'. With Cnut on the throne of England, Edward and his brother were sent to be under the safe keeping of King Stephen of Hungary. Here Edward married Agatha and three children were born, one being Margaret – 'Aetheling'.

During the reign of Edward the Confessor Margaret and her parents were able to return to England where her father was a pretender to the throne. However, he died shortly after his return. The family were then looked after by the Confessor.

Malcolm Canmore, now a widow, was attracted to Margaret and they married in 1070. Margaret had fled to Scotland with her brother Edgar, others of the family, and other Saxon nobles after the Norman Conquest of 1066. It is not entirely clear if the party was heading for Scotland or if it had been blown off course while heading elsewhere, possibly Hungary. The former is a possibility as Malcolm was open to receiving exiles from the south.

Margaret turned out to be one of the most influential figures in Scottish history. She was a much-revered queen and was to become one of a small handful of Scottish female saints.

With the choice of the new Forth crossing being the 'Queensferry Crossing', it helps us remember the meaning of the title. We travel from North to South Queensferry regularly without thinking of the meaning of the name.

The Queensferry forms two towns – North Queensferry and South Queensferry. It was here at a small bay named St Margaret's Hope, near Rosyth Castle, that Margaret landed with her brother Edward and the Saxon party. And it was near here too that a free ferry and hostels were later endowed by Queen Margaret for pilgrims to St Andrew's.

Following their wedding, said to be at the site of Malcolm's Tower, Malcolm's seat of power in what is now Dunfermline, Margaret turned out to be highly influential force on her loving but warlike husband.

She was also a pious and devout woman with a great sympathy towards the poor and the destitute whom she clothed and fed in great numbers. Together, there were eight children: six sons and two daughters, all raised in the Catholic Church. Margaret played a huge role in modernising the Church and is credited with the emergence of a period of enlightenment in both religious and secular affairs. She also revived the monastery on Iona and had St Oran's Chapel built there too. She founded the monastery at Dunfermline. While not large in her time, it was to go on to become one of Scotland's great abbeys, built by David I.

Margaret was canonised as a Catholic saint by Pope Innocent IV for her life of holiness, devotion to others and for her work for the Church.

In 1093, Malcolm, along with their oldest son, was killed during the Battle of Alnwick. Margaret did not long outlive her husband, dying on 16 November 1093 at Edinburgh Castle. Following her canonisation her body was then interred before the high altar in Dunfermline Abbey. However, her remains were removed following the Scottish Reformation but subsequently lost. Apparently, Mary, Queen of Scots had already removed the head believing that its presence might help her in childbirth. It was a time of great superstition!

St Margaret is remembered in the naming of many Scottish churches and institutions and her continued popularity has also been recognised in a yearly pilgrimage in Dunfermline.

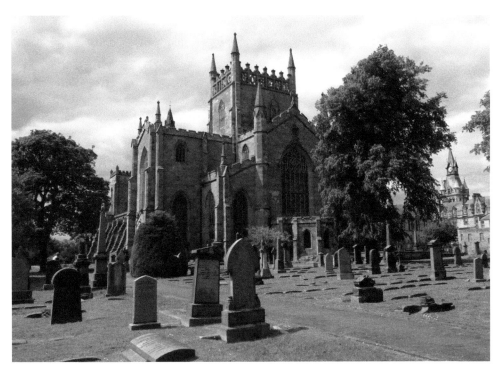

Dunfermline Abbey and St Margaret's Shrine. The sculpted motto round the tower says 'King Robert The Bruce', who is also buried there. (Michael Meighan)

Scotland's Viking Past

It is well known that from the eighth to the fifteenth centuries Vikings, sailing in their longboats from Scandinavia, raided, colonised and enslaved much of the islands surrounding the north and west of Scotland as well as Caithness and Sutherland. This included Orkney and Shetland, the Hebrides and the islands of the Clyde Estuary. In 806 the monasteries on Iona were sacked, killing sixty-eight monks.

Very recently, on the Ardnamurchan peninsula a rare Viking burial has been discovered in which a warrior was buried in a boat along with his decorated weapons. However, while there are few other solid remains of Viking Scotland, it is well remembered in place names and in language, particularly of Orkney and Shetland. In Shetland the yearly Up Helly Aa winter festivals commemorate Viking days and end with the ceremonial burning of a Viking longboat.

There are records showing that Vikings had been raiding along the coasts of the British Isles from the eighth century and that settlements may have begun soon after this. It is thought that resistance to the Vikings contributed to the gradual joining of tribes to form the kingdom of Alba under Kenneth MacAlpin in 843.

Following the sacking of Dumbarton Castle (then Alt Clut) in 878, Govan, now in Glasgow, became a major town in their new kingdom – Strathclyde.

Govan as the centre of the Viking estate is marked by the Govan Stones held in Govan Old Parish Church in Glasgow. The most important is a sarcophagus that was found

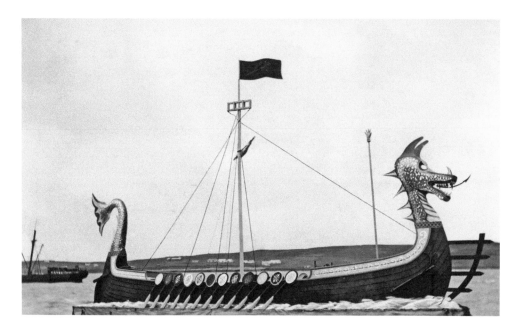

Above: Viking longship in Shetland – waiting to be burned.

Left: Hogback burial stones in Govan Old Parish Church. (Courtesy of Govan Parish Church)

during excavations in 1855. While the carvings are thought to be much later, it is thought to contain the remains of Saint Constantine, a contemporary of St Mungo. The stones are some of Scotland's earliest Christian carvings and include unusual Viking 'Hogback' stones. It is well worth a trip to the Govan Stones visitor centre there. It really is a most beautiful church and new finds continue to be made there, and this is helping us reassess the Scandinavian influence on Scotland.

The Battle of Largs, 1263
The western Hebrides islands of Scotland and the Isle of Man had been under Norwegian sovereignty for many years since Edgar of Scotland had signed them over to Magnus III

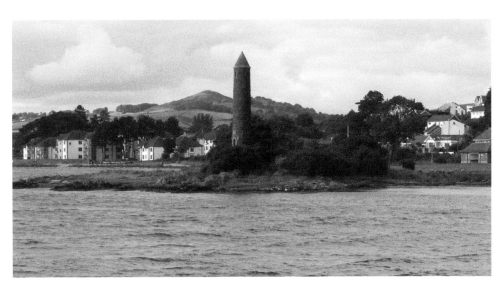

'The Pencil' marking the Battle of Largs in 1263. (Michael Meighan)

of Norway in 1098. Under Alexander III of Scotland, the Scots had tried to purchase the lands but this had been rebuffed. When they resorted to force, Norwegian King Haakon set sail with a massive fleet to reassert control of what the Norwegians called the Sudreys, their Southern Isles.

On the night of 30 September 1263, the ships of King Haakon, which were occupying the Firth of Clyde, were driven ashore in stormy weather near Largs. On 2 October a Scottish army commanded by the High Steward of Scotland, Alexander of Dundonald, arrived to confront the Vikings. A battle broke out on the beach. After hours of skirmishing with an indecisive result, the Norwegians were able to reboard their boats, sailing north to Orkney to overwinter.

It was here that King Haakon took ill and died. His successor, Magnus Haakonarson, agreed with Alexander III of Scotland in the Treaty of Perth to lease the Viking-occupied western shores of Scotland for a yearly sum. This fell through with Norway's civil wars and Scotland simply occupied the west. However, the control of Orkney and Shetland was ceded to Norway, so while the Scandinavian influence diminished in the west of Scotland, it was to continue in the Northern Isles and to this day many in the Northern Isles do think of themselves as Scandinavians.

The Battle of Largs is remembered by 'The Pencil', a tower on Craig Walk on the shore at Largs. The Pencil Walk takes you 2 km from Largs to the monument and it is a fine place for a picnic. Each autumn at the Largs Viking Festival there is a re-enactment of the battle, held beside The Pencil.

While you are in Largs you might also like to take the short ferry trip to the delightful island of Cumbrae, which is brilliant for both easy walking and cycling.

Kompani Linge, Glenmore

Before we leave the subject, you might like to know that Norway is commemorated in a very different way on a plaque at Glenmore Lodge in the Scottish Highlands. For it is here

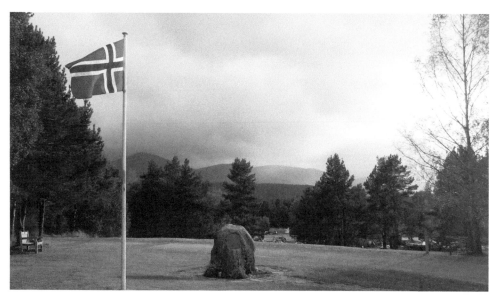

Glenmore monument to the Kompani Linge: 'You opened your homes and your hearts to us and gave us hope.' (Michael Meighan)

that Norwegian commandos trained to launch attacks on a German heavy water plant and other activities within their own country. The raid on the plant at Rjukan was made into a famous film, *The Heroes of Telemark* starring Kirk Douglas and Richard Harris.

Facing the twin terrors of Nazi soldiers and the impregnable fortress factory, against all odds they succeeded in totally destroying the plant, putting back the Nazi plans for constructing an atom bomb. You can read the full story of the raid in the Hostelling Scotland hostel at Glenmore. The monument and flag stands outside the Glenmore Visitor Centre. Glenmore is a beautiful place worthy of a visit at any time of the year.

William Wallace and the National Wallace Monument, 1270–1305

In 1286 Alexander III of Scotland died, leaving his granddaughter as his heir to the Scottish throne. Three-year-old Margaret, the 'Maid of Norway', was betrothed in a marriage treaty to Edward of Caernarvon, the son of Edward I. The treaty declared, however, that Scotland was still a separate nation and that the marriage would have no effect on this. However, wee Margaret died in Orkney on her journey from Norway to her new kingdom. With her death, there were thirteen rivals for the throne and all hell broke loose.

Edward I agreed to arbitrate but also declared that he should be recognised as Lord Paramount of Scotland. The claimants to the throne, many of whom already had estates in England, agreed to his terms, particularly as he had brought a rather large army with him. The resultant arbitration established John Balliol as king in 1292.

However, when Edward insisted that the Scots provide troops for a subsequent invasion of France, the response to this was to defy Edward's orders and create a truce with France, which would come to Scotland's help if Edward invaded. This was the origin

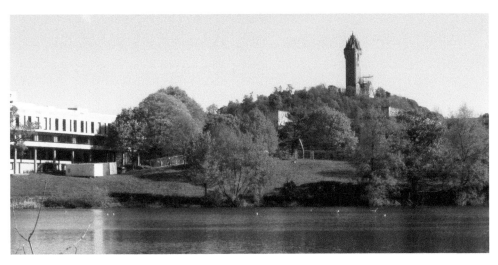

The National Wallace Monument on Abbey Craig, Stirling. (Michael Meighan)

of the 'Auld Alliance' that would come in useful in the future as well as causing difficulties in forthcoming religious issues.

Edward's response to this affront was the sacking, in 1296, of the town of Berwick-upon-Tweed, with the killing of around 8,000 men, women and children. Berwick was then one of the most important towns in Scotland and the assault was said to be one of the most brutal episodes in our history, with the town never recovering its previous status.

Following the sacking of Berwick, the Scots were harried and then defeated at the Battle of Dunbar with King John Balliol then being stripped of his crown and held by Edward in the Tower of London. Dunbar was a humiliation for the Scots. There were thousands of deaths and 130 nobles were captured. Edward then continued his advance, sacking Scottish castles. His attack on Scone and the removal of the Stone of Destiny to Westminster Abbey signaled that no more Scottish kings would be crowned upon it.

Edward then called a parliament at Berwick where the Scottish nobles were required to pay homage to him as King of England. Those nobles were recorded on what became known as the 'Ragman Rolls'. Scotland was at his mercy, well and truly defeated. Except of course, this is where the hitherto unknown William Wallace came onto the stage.

In 1297, following the humiliation at Berwick, in his first acknowledged rebellious act, Wallace murdered the High Sheriff of Lanark, William Heselrig. It is not clear how this came about – whether it was an isolated incident, or whether Wallace was a part of a wider response to the capitulation of the Scottish nobles. Whatever the origins, the uprising continued with Wallace winning increasing support for his insurgency.

His was not the only resistance. In the south-west, nobles had also rebelled but this had been put down easily by Edward's forces and the nobles surrendered at Irvine in the same year, 1297.

Wallace was then joined by Sir William Douglas, 'the Hardy', in raiding Scone to kill Edward's governor, William Orsby. With the proceeds liberated from the English treasury at Scone Abbey, Wallace was able to further his advances. Being joined with other patriots

including Andrew de Moray and Robert Wishart, bishop of Glasgow, he faced the English at Stirling Bridge, the first battle in the Scottish Wars of Independence. It was the Earl of Surrey who had faced down the Scots at Dunbar and thought that he was up against the same rabble.

The bridge at Stirling was then only able to carry two horsemen abreast. The Scots took up the flat, soft ground north of the bridge. One Scottish knight, on the side of the English, proposed outflanking their foe by crossing a nearby ford in numbers. However, a direct attack was ordered by the ill-advised earl.

On the morning of 11 September, the Scots held back as the English crossed. When they felt that they could deal effectively with those who had passed over, they attacked. 5,400 English were confronted by Scots pikemen who descended from the high ground and quickly took control of the area north of the bridge.

The vanguard of Surrey's army was cut off and savagely dealt with by the Scots. His army was reduced and although he still had the bulk of it, and while he could probably have held the south side of the Forth, he retreated to Berwick, abandoning the garrison at Stirling. While Wallace went on to greater things, Moray was injured in the battle and died in the November. Wallace then followed up his victory by leading an attack into the north of England.

Edward I was having none of this. Returning from Flanders, he gathered together an army of 15,000 and pursued Wallace to Falkirk where their forces met. The Scottish army was destroyed, leaving Edward in charge in the south of Scotland. It would be a long time before Edward's rule could be challenged. While Wallace had escaped, he was pursued and finally captured in Robroyston near Glasgow and taken to London where he was hanged, drawn and quartered.

The National Wallace Monument sits on Abbey Craig above Stirling. It is a relatively modern structure having been erected through public subscription in the nineteenth century and completed in 1869. A group of prominent Scottish businessmen formed a

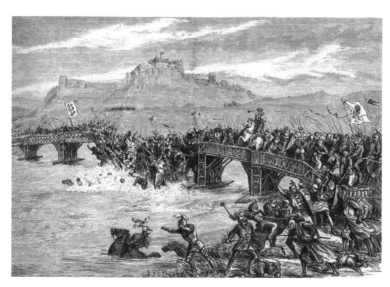

An artist's impression of the Battle of Stirling Bridge. (Michael Meighan Collection)

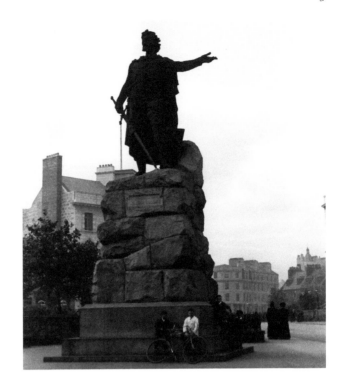

Aberdeen statue of
William Wallace.
(Michael Meighan Collection)

committee in 1830 to take it forward, but it was not until 1869 that the tower was finally completed. By the way, the originally preferred site was Glasgow Green but Abbey Craig won the day. At its opening there were 70,000 present.

The designer was John Thomas Rochead, a prominent Scottish architect whose works included The Royal Arch in Dundee and Buchanan Street railway station in Glasgow.

The tower continues to attract thousands of visitors yearly, some because of the Hollywood blockbuster *Braveheart* starring Mel Gibson. While it may be the largest, there are many other monuments to Wallace. Opposite His Majesty's Theatre in Aberdeen there is a magnificent bronze designed by William Grant Stevenson.

Robert the Bruce, King of Scotland, 1306–29, and the Battle of Bannockburn

Robert the Bruce was one of Scotland's greatest historical figures and the King of Scotland from 1306 to 1329. Bruce's complicated claim to the throne was as the great grandson of a previous Bruce, the 5th Lord of Ananndale, a competitor for the throne following the death of Margaret, the 'Maid of Norway' who died in Orkney on the way to her inauguration at Scone on the Scottish mainland. This meant that there was no recognisable heir to the Scottish throne.

King Alexander III of Scotland died in 1286 without leaving a male heir, his throne going instead to his three-year-old daughter Margaret whose interests during her early years were looked after by a system called the 'Guardians of Scotland'. This must have been very powerful as the Guardians drew up a marriage contract between herself and Edward Caernarvon, the heir to the English throne.

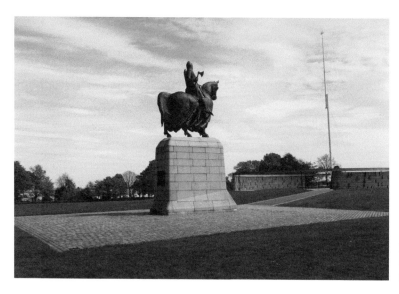

Robert the Bruce
at Bannockburn.
(Michael Meighan)

One contender for the crown was Sir John 'Red' Comyn, Lord of Badenoch, who was a leading Scottish baron and one of the Guardians of Scotland. There was bad blood between Comyn and Bruce. Comyn's father, John 'Black' (obviously a very colourful family), had attacked Carlisle Castle when Bruce's father had been Constable.

At a meeting in Dumfries, emotions got out of hand and the Bruce stabbed Comyn in front of the high altar in the Greyfriars Kirk. Stabbing anyone in front of the altar was considered extremely bad form by the Catholic Church, so he was promptly excommunicated as well as being outlawed by Edward I. Edward, 'The Hammer of the Scots', alias 'Longshanks', was on his last legs by this time. The Comyn family was not at all pleased either and this prompted a bloody war between Comyns family and followers of Bruce.

Bruce had nothing to lose after the murder and decided it would be a good time to seize the throne. He had himself crowned in a very small ceremony at Scone. This was the start of his campaign for Scottish independence. Following a number of skirmishes, the first real battle with the English ended up with a rout of Bruce's army at Methven. Edward had appointed Aymer de Valence, Comyn's brother-in-law, as his authority in Scotland and told him to get after Bruce and to give him no quarter.

While squaring up to each other, both came to a gentleman's agreement that they would get on with the fight in the morning and not bother to post pickets. However, no wonder the English get a bad name up here because Valence did a dastardly thing by attacking in the night and routing Bruce's army.

Bruce was taken captive but he was held by a Scottish knight who let him go rather than see him killed. However, many of Bruce's supporters and followers were brutally killed. Bruce fled to the west and on to Rathlin Island, off the coast of Ireland and near to Scotland.

Now, let's move from fact to fiction and Bruce's unlikely encounter with a spider. This was supposed to have happened on Rathlin Island, off Ireland, or Kirkpatrick Fleming near Lockerbie or Drumadoon on Arran, or the Hebrides, or several other places in

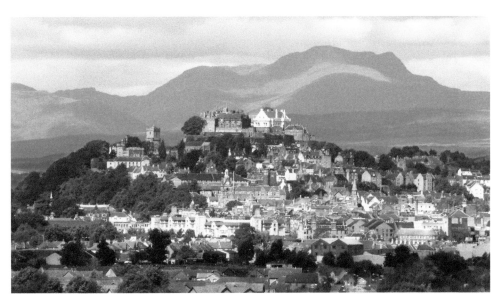

The magnificent Stirling Castle is a Scheduled Monument. (Courtesy of Stirling Council via Flickr)

Scotland. The story goes that having failed in his attempt on the throne he was on the run from the vengeful English and took refuge in a cave where, in a slough of despond, he despaired of his position. However, his attention was taken by a spider that was trying to attach itself to a wall in order to weave its web. Time and time again it would fall off but eventually it managed it. Watching this, Bruce was apparently galvanised into action and realised that he should try, try and try again with his attempts at the Scottish crown.

Whatever motivated him, he decided to have another go at the crown. Leaving Rathlin, he joined with the Black Douglas and his other followers. From 1307 to 1314 he campaigned throughout Scotland, burning and sacking the castles of his opponents. During this time he had changed his tactics from the image of the feudal knight to a highly successful guerrilla leader. All of this came to a head at the Battle of Bannockburn in 1314 when Edward II came north to personally supervise the relief of strategically important Stirling Castle, which was being besieged by Bruce's brother Edward.

Over two days, the English army was soundly beaten. Bruce used ploys such as digging pits to force the enemy onto constricted paths as well as using guerrilla tactics. The small size but high morale of the Scottish army is also said to have had a huge influence on the outcome. The English collapsed and dispersed, Edward fleeing to Dunbar from where he took ship to England. The English army was harried all the way to the border.

While the Battle of Bannockburn was significant, it wasn't really the end. Scottish independence and Bruce as king were not recognised by Edward until 1328. Even then with his son David on the Scottish throne and Edward III once more promoting a Balliol to the throne the old conflict was renewed.

However, Bruce had brought some stability to the land. The Declaration of Arbroath smoothed the way for the lifting of his excommunication and recognition of his sovereignty by the Vatican.

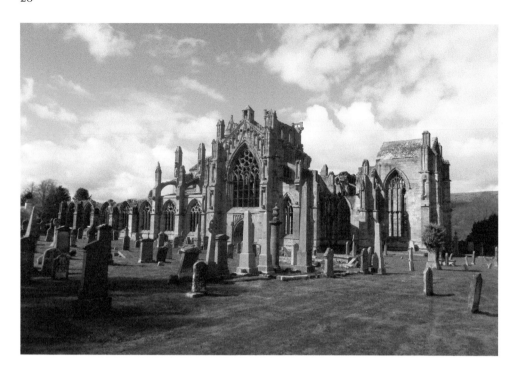

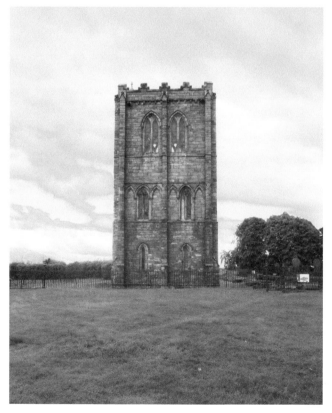

Above: St Mary's Abbey, Melrose, is a Scheduled Monument. Alexander II and other Scottish kings are buried here. (Michael Meighan)

Left: Cambuskenneth Abbey is a Scheduled Monument. It was where the Bruce held his parliaments in 1314 and 1326. It is also the burial place of King James III and his wife Margaret. (Michael Meighan)

Bruce died in 1329, to be succeeded by his son, but under the guardianship of the Earl of Moray as he was only five. Bruce's grave is in Dunfermline Abbey but his heart is interred at St Mary's Abbey, Melrose.

> ...for, as long as but a hundred of us remain alive, never will we on any conditions be brought under English rule. It is in truth not for glory, nor riches, nor honours that we are fighting, but for freedom – for that alone, which no honest man gives up but with life itself. (From the Declaration of Arbroath)

Flodden Memorial, Northumberland, 1513

Not limiting this book to Scotland, I travelled over the border to Branxton, in Northumberland, to the battlefield of Flodden. It was here that the 'Flowers of the Forest were 'a wede away'. This poem set to an old air was written by Jean Elliot in 1756. This powerful and popular ballad laments the deaths of James IV and as many as 10,000 men on the battlefield of Flodden. The farm girls are bemoaning their lost menfolk:

> I've heard the lilting, at the yowe-milking
> lassies a-lilting before dawn o' day
> But now they are moaning on ilka green loaning
> The Flooers o' the Forest are a' wede away
>
> Dool and wae for the order sent oor lads tae the Border!
> The English for ance, by guile wan the day,
> The Flooers o' the Forest, that fought aye the foremost,
> The prime o' oor land lie cauld in the clay.

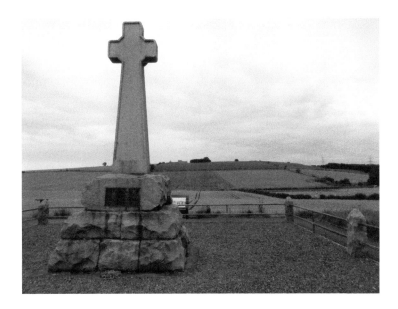

Flodden Memorial,
Branxton,
Northumberland.
'To the brave of
both nations'.
(Michael Meighan)

Flodden had its origins in the 'Auld Alliance' of Scotland with France agreed in a treaty in 1295 providing mutual protection against English attacks. James IV, King of Scots, declared war on England with the intention of diverting Henry VIII's English troops from attacking the French. Henry had been at war with France and James had been persuaded to renew the alliance. He didn't need much persuasion as Henry had also been claiming the overlordship of Scotland.

James' pretext for the invasion was the murder of Robert Kerr, a Warden of the Scottish East March who had been killed by 'The Bastard' John Heron in 1508.

Arms and money from France were sent allowing James to assemble an invasion force, and at Milfield Plain near Wooller, a first, but minor, skirmish was the precursor to James crossing the Tweed at Coldstream on 22 August with an army of 30,000 men.

The battle was fought between James' invading army and the English army commanded by the Earl of Surrey. It was the biggest battle ever fought between the two nations and it did not go well for Scotland. With the Scots forced to reverse their position through Surrey's wily tactics, they were showered with long-range artillery bombardments and volleys from archers.

The Scots pikemen charged down the hill and were repulsed by the bills (pole weapons) of the English foot. At the end of that sad day, 10,000 Scots lay dead along with their king and many nobles.

The effect of the loss of so many young men was felt most in the Scottish Borders from where many of those who had died were recruited. While there is a memorial cross at Flodden, perhaps the most poignant monument to the dead is in Selkirk where the Fletcher Memorial remembers the return of the only survivor of eighty young men who joined the battle. A generation had been wiped out. Perhaps even more significant is the

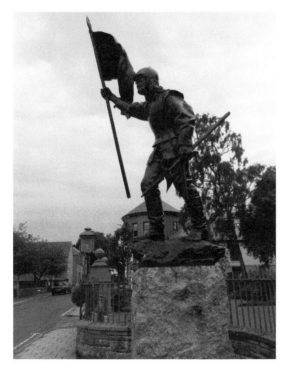

The Fletcher Memorial, Victoria Halls, Selkirk. (Michael Meighan)

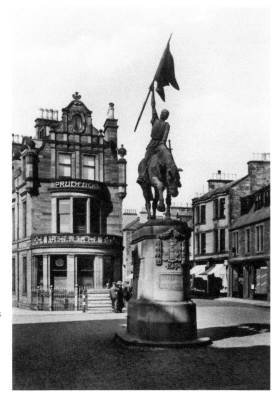

The 1514 Memorial Hawick commemorates a victory by local youth over the English at Hornshole in 1514, just after the Scots defeat at Flodden. A rider returns from the skirmish holding aloft an English banner. (Michael Meighan Collection)

more modern garden commemorating the fortitude of the women and children that were left bereft. It is at Victoria Halls beside the Fletcher Memorial.

It is said that young Fletcher, the survivor, returned exhausted to the town square with a captured English banner, casting it to the ground before he died. This event is re-enacted each year at the Selkirk Common Riding.

Among the many commemorations of Flodden is Walter Scott's 'Marmion' and the *Marmion Overture* by Arthur Sullivan.

Mary, Queen of Scots, 1542–87

Mary, Queen of Scots vies with Bonnie Prince Charlie and Robbie Burns as the most romantic figure in Scotland's past. While Robert Burns gave us a legacy of song and poetry, it is hard to say what the adventures of Mary and Charlie actually achieved. We will address Charles later but let's look first at Mary.

Mary was the surviving legitimate child of King James V, and granddaughter of James IV, who died at Flodden. She was only six days old when her father died. While she acceded the throne, Scotland was actually ruled by regents while she stayed in France, eventually marrying Francis, the Dauphin (or heir apparent). When he became king she briefly became queen consort until his untimely death through illness in 1560.

In 1561 Mary returned as a young widow to Scotland and four years later married her first cousin Henry Stuart, Lord Darnley. However, their marriage became strained. Mary

32

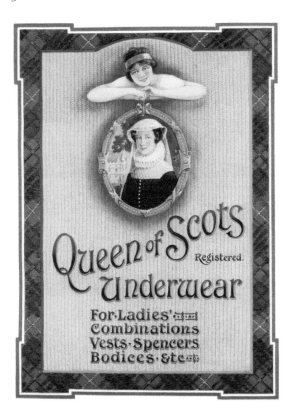

Left: From 1915, Mary, Queen of Scots helps to sell underwear. (Michael Meighan Collection)

Below: Mary, Queen of Scots surveys her birthplace, Linlithgow Palace. Under the care of Historic Environment Scotland, this is a great visit to a historic town. (Michael Meighan)

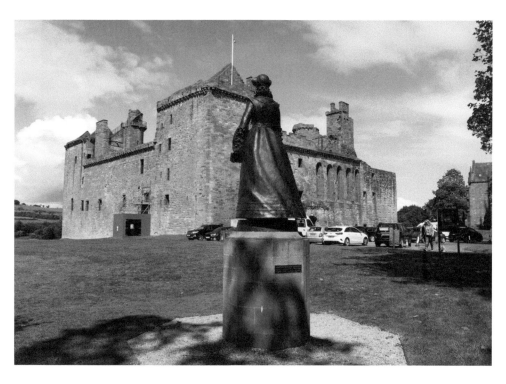

had turned down Darnley's request to be a joint ruler and meanwhile she had become extremely close to her private secretary David Rizzio, possibly the father of her child.

An enraged Darnley conspired with Protestant lords to murder Rizzio in front of Mary during a dinner at the Palace of Holyroodhouse.

In 1567 Darnley's house was destroyed in an explosion and Darnley was found dead in the garden, murdered. It is believed that this was the doing of James Hepburn, 4th Earl of Bothwell. He was acquitted of this and very shortly after married Mary.

However, Mary was treated with great suspicion in Scotland, given that she was a practicing Catholic in a Calvinist country and her marriage was strongly opposed by Scottish nobles. They rebelled against her and took her into custody.

Forced to abdicate, she was held captive in Loch Leven Castle while James Stewart, Earl of Moray, was appointed Regent in place of her infant son, James VI. She managed a famous escape with the help of George Douglas, brother of the castle's owner, Sir William Douglas of Loch Leven. Douglas stole the castle keys and, dressed as a servant, she was rowed across the loch to where Douglas waited with 200 horsemen.

Langside may be quiet and leafy now but here the Battle of Langside was fought on 13 May 1568. With an escort drawn from the Scottish nobility, in a very short time Mary had gathered a force of 6,000 loyal followers with the intention of entrenching herself at Dumbarton Castle to wait for reinforcements before challenging for the throne.

Here, at Langside, her forces, led by an inept Earl of Argyll, Archibald Campbell, were defeated by Regent Moray. She fled to England expecting her cousin Elizabeth I to help her regain the throne. However, she was put into protective custody at Carlisle Castle and eventually beheaded. Mary had previously made it clear that she had a claim to the

Monument to the Battle of Langside, Battlefield Place, Langside, Glasgow. (Michael Meighan Collection)

throne of England and her intrigues towards this, particularly in what was known as the Babbington Plot, finally persuaded Elizabeth to put an end to her.

If you visit the monument on Battle Place in Langside then do visit the adjoining Queen's Park. Named after Mary, it is one of Glasgow's great public areas and has wonderful views across the city.

John Knox, Leader of the Scottish Reformation and Founder of the Presbyterian Church of Scotland, 1513–72

Mary, Queen of Scots was treated with suspicion in Scotland, and to the fore protesting her wicked Catholic ways was John Knox, whose statue can be seen within New College, on The Mound, in Edinburgh.

Educated at St Andrews University, Knox was involved in a movement to reform the Church in Scotland. While Christianity was probably introduced to southern Scotland during the Roman occupation, the Church of Scotland can trace its ancestry back to missionaries who spread a different form of Christianity that came from Ireland in the fifth century and is associated with St Ninian, St Columba and St Kentigern.

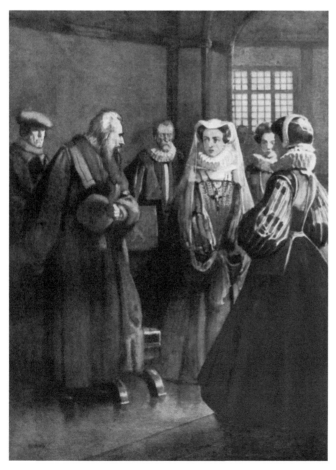

Mary and John Knox did meet in Edinburgh and there is no evidence that their meetings were acrimonious. (Michael Meighan Collection)

In the mid-seventh century these two branches of the Catholic Church came together when the Roman version was accepted. However, over a period of time the practices of the Church came under scrutiny and reformers wanted it to turn away from what they saw as greedy, decadent and corrupt practices including the sale of indulgences – that is the promise of remission of sins. They also repudiated the authority of the Pope over Scottish religion.

The Reformation was European wide and at the heart of these huge changes in Scotland was John Knox, whose influence on Scottish religion, life and culture was indeed enormous.

Central to this was Knox's sermon in Perth. He had spent many years in captivity and exile before returning to Scotland where he was met by many Protestant sympathisers but was declared an outlaw by the Queen Regent, Mary of Guise. In the Church of John the Baptist, Knox produced a fiery sermon which roused the Protestant mob to violence. They went on to sack local friaries, stealing gold and silver religious artefacts.

The death of Mary of Guise in Edinburgh Castle brought to an end the period of violence and rebellion and following her death the Scottish Reformation Parliament ended the jurisdiction of the Roman Catholic Church in Scotland. The first meeting of what was to be the General Assembly of the Church of Scotland was held soon after. A religious revolution had taken place but without the civil war that was feared.

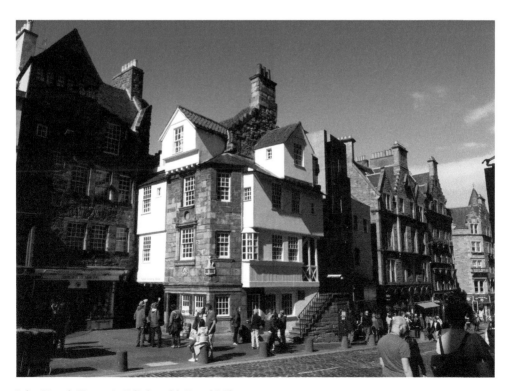

John Knox's House in Edinburgh's Royal Mile.

The Wigtown Martyrs and the 'Killing Time', 1680–88

An unusal memorial to the Wigtown Martyrs in the Old Town Cemetry in Stirling depicts Margaret Wilson reading the Bible with her younger sister Agnes. A guardian angel watches over.

What if your passion for a particular religion took you into conflict with the established church to the extent that you would be forced to recant your beliefs? If this was not done, you would be beaten, imprisoned, then tied to a stake at sea to allow the tide to cover you as it came in. Even as the water rose around you, you would continue to shout your refusals and this would be silenced as your head was thrust under the rising tide until you drowned.

We are nowadays used to such stories of religious persecution and horror in the Middle East. This story, however, was far closer to home. Religious intolerance and sectarianism has been a feature throughout Scottish history, and from this history one particular episode stands out: the drowning of 'The Wigtown Martyrs', Margaret McLachlan and Margaret Wilson, in the Solway Firth in 1685. They were executed in a most cruel way having been tied to stakes in the Solway Firth while the tide came in to cover them as onlookers watched from the shore.

In 1643 the Solemn League and Covenant was an agreement between the Scots and the English in which the Scots agreed to support the English parliament to protect a Presbyterian religious and political union in both countries. However, while the Scots gave military assistance in England, neither Oliver Cromwell's Commonwealth or, following the Restoration of 1660, King Charles II took any notice of the Covenant.

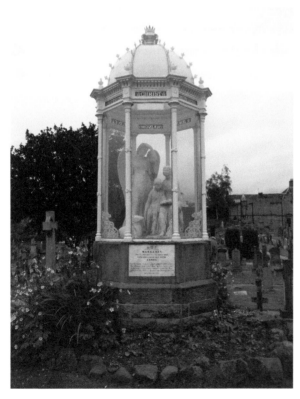

An unusal memorial to the Wigtown Martyrs in the Old Town Cemetry in Stirling. (Michael Meighan)

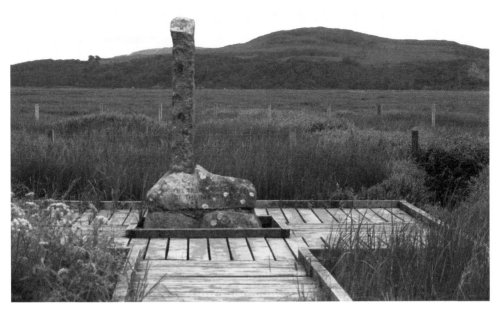

Monument to both Margarets at the place where they were drowned, now just marshland. (Michael Meighan)

Covenanters were expected to swear the Oath of Abjuration, a formal rejection of the National League and Covenant of 1643, which would ensure the rooting out of dissenters and it was this measure that was to cause the martyrdom of the two Margarets who refused to swear the oath.

In what became known as 'The Killing Time', rebellion was crushed through fines, torture and assassinations. Much of this in the south-west was carried out by 'Bluidy Clavers', John Graham, Laird of Claverhouse, acting on behalf of Charles II.

The lonely commemorative stake, where they were drowned, is set in the marshes on the Firth and is possibly the most poignant memorial of many monuments to the Covenanters throughout Scotland. Their graves are in the nearby parish churchyard and they are also commemorated on a separate monument on Windy Hill, above the town.

Wigtown, on the Solway Firth, in Dumfries and Galloway, is also known as Scotland's National Book Town. It is a quiet county town that comes to life during its Book Festival. An interesting town walk takes you around the monuments and places associated with the martyrs.

The Massacre of Glencoe – 'The Glen of Weeping', 1692

Since 1603, Scotland and England had shared a monarch. King James VI and I, King of Scots, had acceded to both the thrones of England and Ireland in March of that year. This was a personal union in that the kingdoms remained politically independent, with their own parliaments and laws. The union followed the death of Elizabeth I of England who was James' first cousin twice removed.

The Glencoe
Monument in
Glencoe Village.
(Michael Meighan)

This union was brought to an end with the execution of James' son Charles I in 1649, with England becoming a republic. Charles believed in the divine right of kings and an absolute royal prerogative. His tyranny offended his subjects, as did his marriage to a Roman Catholic. He fell out with Parliament and this led to the English Civil War.

During this time, Scotland retained the monarchy, proclaiming Charles I's son, also Charles, as king. However, Charles II was defeated by Oliver Cromwell at the Battle of Worcester in September 1651, the last battle of the English Civil War (although the Royalist troops were mainly Scottish). Charles fled to France.

In 1660, the monarchy was restored with King Charles II coming from exile to take up his throne, being crowned at Westminster Abbey in April 1661. 'The Merry Monarch' fairly enjoyed himself during the Restoration, the name for the years after Charles acceded to the throne. While he had no children with his wife Catherine of Braganza, he acknowledged twelve illegitimate children, two of them with his famous mistress Nell Gwynne.

After his death in 1685 Charles was succeeded by his brother, who became James II of England and Ireland and James VII of Scotland.

James was unpopular in Scotland. He was a Catholic in a Calvinist country and also unacceptably autocratic. The 'Glorious Revolution' in 1688 brought an end to James' reign, when he was replaced on both thrones by the Protestant William of Orange, his Dutch son-in-law. There had been a gathering opposition to James' Catholicism, religious tolerance and ties with France. The birth of his son, James Francis Edward Stuart, dangerously promised a Roman Catholic monarchy. Tories and Whigs united to invite the Protestant William to invade. William was the husband of James' first child Mary, an Anglican. After a successful invasion William and Mary went on to run the country

jointly. James and his Jacobite followers fled to France. The term 'Jacobite' is usually connected to Prince Charles Stuart, the 'Young Pretender'. In reality, the term is derived from the Latin for James.

From 1688, a succession of Jacobite rebellions was a thorn in William's side. The first, the Battle of Killiekrankie in 1689, was a much-feted success for the Jacobites but with the strength of the British army against them, it was a short-term victory as they were soundly defeated at the Battle of Dunkeld a month later.

The rising persuaded William to strengthen his garrisons in the Highlands to control the clan chiefs. He built a substantial fortress that was to become known as Fort William, and from here and other fortresses he was to reach out and punish the Jacobite MacDonalds at the Massacre of Glencoe in 1692.

The massacre is considered to be the most heinous of violent actions in Scotland's past and has cast a long shadow over relationships between the clans.

Following the defeat of the Jacobites, clans were called upon to pledge allegiance to William III. A deadline of 1 January 1692 was set for the acceptance of oaths with severe reprisals promised if clans did not sign up.

Twelve days before the massacre, soldiers arrived in Glencoe and were offered shelter according to clan customs. However, there were already orders for the troublesome Macdonalds of Glencoe (or MacIains) to be slaughtered – 'cut off root and branch'.

On the night of 13 February, with a blizzard blowing, the soldiers received their orders and set about the massacre. In the cold, bleak morning thirty-eight lay dead. It may have been more if some of the disgusted Campbell soldiers had not warned their hosts.

When details of the massacre were heard in Edinburgh, an enquiry was held and the Scottish parliament declared it an act of murder. The only penalty seems to have been the dismissal of the main architect of the order to massacre, John Dalrymple, the Master of Stair. However, the outrage lives on in Scottish memories.

King William of Orange was also celebrated in Glasgow. Here he is riding a horse on a statue sponsored by an admirer in 1735. While it originally sat outside the Glasgow city headquarters, following continuous vandalism it was finally moved to a quieter location in Cathedral Square. (Michael Meighan Collection)

Bonnie Prince Charlie and the '45', 1745–46

Charlie Raises the Standard

The undisputedly most romantic period in Scotland's history is the story of Bonnie Prince Charlie, the 'Young Pretender', whose attempt at reclaiming the crown of Scotland for the Stuart dynasty began at Glenfinnan where he raised his standard, beginning what became known as the '45' in 1745.

The rising in 1745 took most people by surprise, not just because it was unexpected but because it was grossly underfunded, had little support from the clan chiefs and from Scotland's allies in Europe. The French government thought it a bad idea as any foray would have been stopped by the British fleet. It was hardly a year since an abortive invasion of Britain by France was stopped by bad weather. This invasion would have put Charles on the throne and he was frustrated by the failure. This may have made him act rather foolishly when he decided to invade on his own initiative the following year, because it was mainly the work of Charles himself who firmly believed in his own destiny. He thought that he had the support of Highland Clans for an uprising as he had had a message that if he arrived with at least 3,000 French troops, the clans would rise.

With the financial assistance of exiled Scots bankers he fitted out the privateer Du Teillay and the ship of the line, *Elizabeth*. They carried 700 volunteers.

The project was to start as badly as it was to conclude with the ships being attacked by the HMS *Lion*. The *Elizabeth* was forced to return. Charles was left virtually alone, except for seven companions on the Du Teillay, which eventually landed with his 'Seven men of Moidart' on Eriskay in the Outer Hebrides on 2 August 1745.

There was less enthusiasm for Charles' expedition than he had hoped for and some clan chieftains refused to meet with him. At the raising of the standard at Glenfinnan he had collected only 1,200 supporters. Eventually, by the time he started his march south around 3,000 men had gathered to the cause.

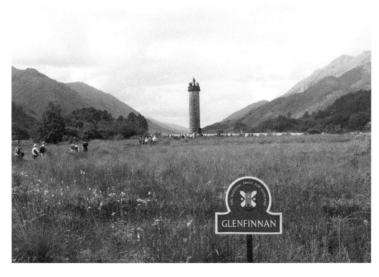

Glenfinnan Monument marks the spot where Prince Charlie raised his standard having arrived by boat from France. (Michael Meighan)

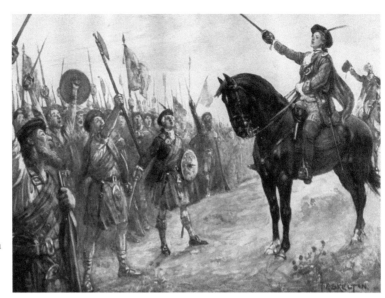

'Gentlemen', he
cried, 'I have thrown
away the scabbard.'
(Michael Meighan
Collection)

With a great proportion of the British army engaged in the War of the Austrian Succession, in Flanders and Germany, Charles had an advantage, particularly since many of the 4,000 strong British army in Scotland, under Sir John Cope, had little experience of soldiery, consisting as it did mostly of recruits and soldiers unfit for service.

One of the misconceptions about the '45' is that the military road built by General Wade was in response to this threat from the Young Pretender Charles. In fact, it was built after the previous Jacobite rebellion, the '15', to allow quick military response to any threat in the north.

In this it failed badly. While the new road was a welcome development for many in the Highlands, the greatest benefit was actually to the Jacobite army that was able to travel swiftly down the new road where they camped at the Corrieyairack Pass. This might have been the site of battle but General Sir John Cope decided that his untried army was not up to the test of confronting the well-protected Jacobites. He headed off to Inverness, thence to Aberdeen where he embarked for Dunbar to fight another day.

Charles quickly took Wade's Highland forts, moving on to take Perth and then to Edinburgh where Charles' father, 'the Old Pretender', was proclaimed James VIII of Scotland and III of England and Ireland at Holyrood, even though the impregnable Edinburgh Castle was left intact with its garrison.

The Glenfinnan monument was constructed in 1815 by Alexander Macdonald of Glenaladale to commemorate the raising of the standard. It was designed by James Gillespie Graham. The statue of an anonymous Highlander was added in 1835.

The monument has been in the care of the National Trust for Scotland since 1938. Here, hundreds still gather on 19 August each year to commemorate the rising.

On 17 September 1745 Charlie arrived in Edinburgh where he set up court in the Palace of Holyroodhouse while the Government troops were besieged in Edinburgh Castle at the top of the Royal Mile.

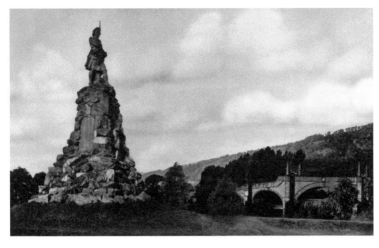

General Wade's Bridge at Aberfeldy is the most imposing of Wade's works. Completed in 1733, it was designed by Robert Adam. It is still in use today. In the foreground is the Black Watch Memorial. (Michael Meighan Collection)

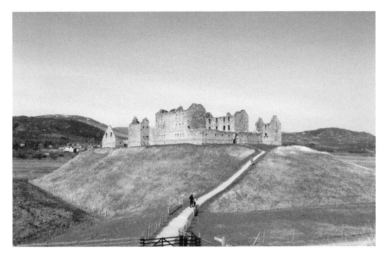

Ruthven Barracks. The barracks survived an attack by the Jacobites on their way south but fell to a larger force the following year. It was here too from where Charlie sent the remnants of his force home, after having been beaten at Culloden. (Michael Meighan)

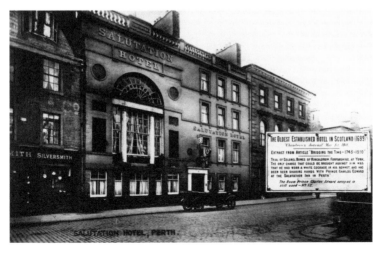

As Charlie moved south he demanded funds to pay his troops and provide food. It is said that he made his plans for his invasion of England here in room 20 of the Salutation Hotel. (Michael Meighan Collection)

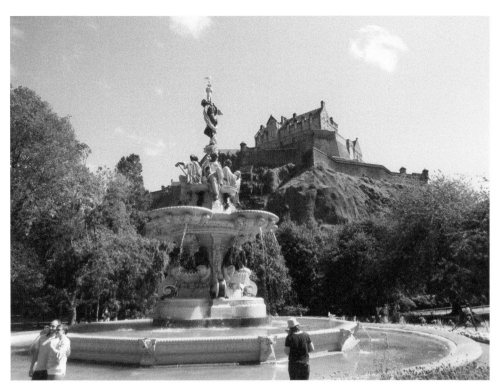

Edinburgh Castle gives a background to Princes Street Garden's magnificent Ross Fountain. (Michael Meighan)

The Battle of Prestonpans, 1745

Charlie spent six weeks in Edinburgh attending balls and debating the next move, while all the time he was losing the element of surprise as Sir John Cope's army had travelled by sea to Dunbar and was moving to confront the Jacobites.

He left Edinburgh at the end of October and headed south, and it was at Prestonpans in East Lothian in September 1745 that the first stand of the Government against the hitherto unopposed Jacobite army was made.

What was originally known as the Battle of Gladsmuir ended in a rout of highly inexperienced Government troops. In the face of a charge by the Highlanders, Sir John Cope's troops broke and fled.

Sir John Cope was both a career soldier and politician who had been fighting in Europe. He was knighted for his role in the victory at the Battle of Dettingen. He had achieved his rank mostly through patronage and while he was appointed head of the army in Scotland in 1743, he was considered an average commander, not brilliant.

Cope's army confronted the Highlanders as they marched south having taken Edinburgh. Remember that the Jacobite Rebellion was intended to be a national conflict but has been interpreted by many as an attempt to put Charles on the Scottish throne. In fact, the Jacobite objective was to restore the Roman Catholic King James Stuart VII and heirs to the thrones of England, Scotland and Ireland. Therefore, it was a wider cause and

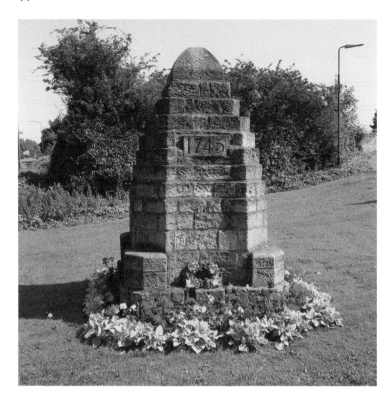

The Battle of Prestonpans memorial, Prestonpans. (Michael Meighan)

why Charles, the Young Pretender, marched south from Prestonpans. It was his strongly held belief that his Highlanders would be joined by strong English Jacobites and would continue south to join a French invasion force to march on London.

There were skirmishes to begin with and then the two sides faced up to one another. After one volley the Jacobites laid into the Government troops, many of whom were raw recruits. Cope fled with 450 troops remaining. It had taken around eight minutes to humiliate Sir John Cope and the British government.

Sir John Cope's inglorious defeat was commemorated in the well-known song by local farmer Alan Skirving: 'Hey Jonnie Cope, Are ye Wauking Yet?' (Are you awake yet?).

> Hey Jonnie Cope, Are ye wauking yet?
> Or are your drums a beating yet?
> If ye were wauking I wad wait
> To gang to the coals i' the morning

The invented story was that General Cope was still asleep when the battle started and had to be woken. The 'coals' possibly refers to the local industry of burning coal to produce salt in the pans, which gives Prestonpans its name. Skirving means that if Cope is coming then he won't go to work but confront the Government troops.

Having taken Carlisle by siege and now with an army of around 4,500, Charles entered Derby. He wanted to press home what he thought was his advantage. However,

his Highlanders were becoming unsettled. At a council of war the view was that there were two British armies between them and London; there was no sign of the English Jacobites, which Charles thought would come out, and the expected French invasion had not materialised. It was thought that if they pushed forward then it was highly unlikely that they would ever get home.

The furious and disappointed Charles acceded and the force turned around. On their way north they were to be involved in minor skirmishes, harried and pursued by Government forces. They finally reached the end in battle with the loyalist troops commanded by Prince William, Duke of Cumberland, who was to become known as 'Butcher' Cumberland for his brutal reprisals after the Battle of Culloden, our next venue. Much of the battlefield has been destroyed by building and its presence was largely ignored for many years, although in more recent times there have been moves to ensure that its remaining legacy is retained intact.

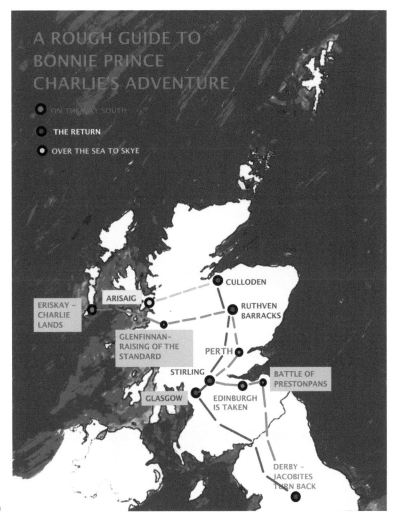

A rough guide
to Charlie's
campaign.
(Michael Meighan)

The Battle of Culloden, 1746

Culloden was the last ever battle to be fought on British soil and it was short and brutal, as were the bloody reprisals in the aftermath. In less than an hour, up to 2,000 men were dead, most of them on the Jacobite side.

It was 16 April 1746. Following the failures of both Generals Cope and Hawley to contain the Jacobites, Prince William Augustus was recalled from Flanders to put a stop to the progress of Charlie, who was becoming quite an embarrassment to the government and to the military, not to mention putting the wind up the English citizen.

The appointment of 'Butcher' Cumberland, as he was to become known, was extremely popular and he set about preparations for pursuing the Jacobites back into Scotland to where they had returned, having found little support in England.

The Jacobites had been pursued from Derby, where they had turned around, but led by Henry Hawley the Government troops were badly defeated at Falkirk Muir, the Jacobites last success. Cumberland by this time realised the futility of trying to overtake the retreating Jacobites.

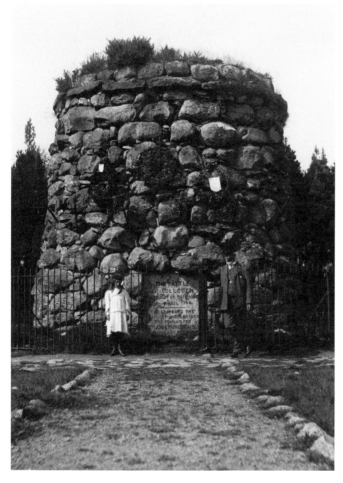

The Culloden memorial.
(Michael Meighan Collection)

He waited out the winter and moved his troops to Aberdeen where they were supplemented by 5,000 Hessian (German) troops. The two armies eventually met just outside Inverness, at Culloden where a now superior Government force confronted the Jacobites. The bloody battle lasted only an hour but it left up to 2,000 Jacobites killed or wounded and fleeing. The bloody aftermath gave the 'The Butcher' his name, with the previously defeated Henry Hawley also extracting his revenge.

Charlie was one of those who fled, whisked away first of all to the Hebrides where he was pursued relentlessly by Government forces. It was here that he met Flora MacDonald, who helped him in his escape to Skye. He crossed to the mainland dressed as a maid of Flora's – Betty Burke. He was eventually picked up by a French ship. He never returned to Scotland. The Jacobite adventure was over.

On the battlefield where you can see the stones of the Graves of the Clans with the visitor centre in the background. (Michael Meighan)

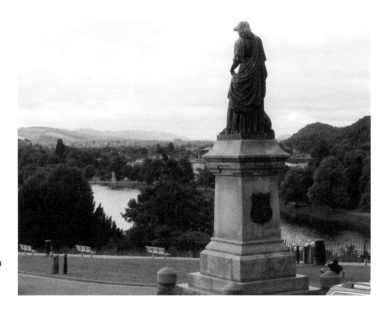

A statue of Flora MacDonald looks towards the west from Inverness Castle. (Michael Meighan)

3. The Tragedy of War

National Monument of Scotland and the Napoleonic Wars, 1803–15

As you pass along the foot of Calton Hill then you might be forgiven if you thought that Athens's Parthenon had been rebuilt in Edinburgh. For there, on the summit, is a Greek temple. It is, in fact, a part-completed replica of the Parthenon whose decorated friezes, the Elgin Marbles, reside in the British Museum.

This is the National Monument of Scotland that was built to commemorate the fallen in the Napoleonic Wars. From 1803 to 1815 the wars were fought between Napoleon's French Empire and various coalitions of European powers with Great Britain to the forefront. The series of wars succeeded the French Revolution and the Revolutionary Wars. The wars and the eventual defeat of Napoleon had severe and lasting consequences for the world. Great Britain was to grow an empire while Spain's and Portugal's were to decline.

It is estimated that 312,000 British sailors and soldiers died in these conflicts and it is to these that the monument on Calton Hill is dedicated.

It was designed around 1824 by Charles Edward Cockerell and William Playfair. Although construction started in 1826, by 1829 it was left unfinished – funds had run out. The remaining structure, now often classed as a folly, is only a vestige of what was intended. It was to have catacombs in which would be interred the great and the good of Scotland – a sort of Valhalla, in Norse legend, the great hall where those who died in battle were led by the Valkyries. There would also be a church, or 'place of Divine worship'. All this would be maintained by the Royal Association of Contributors to the National Monument of Scotland.

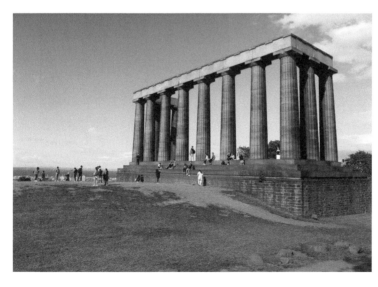

National Monument of Scotland, Calton Hill. (Michael Meighan)

There have been a number of suggestions for completing the monument including as a monument to Queen Victoria and a site for the Scottish parliament. In the event, except for major restorations, it remains much as it was and an iconic part of Edinburgh's landscape, much used by visitors.

Nelson's Monument, Calton Hill, and the Battle of Trafalgar, 1805

The Battle of Trafalgar was a key event in the Napoleonic Wars and it was here that Admiral Lord Nelson died while uttering the phrase 'Kiss me Hardy'. While it might seem improbable, there were, in fact, a number of witnesses to what he said, and in any case, platonic kisses between men were not unusual at the time.

Nelson had been struck by a bullet fired from the seventy-four-gun French ship *Redoubtable*. While the *Victory*'s surgeon William Beatty tried hard to save Nelson and did remove the bullet that had done the damage, unfortunately Nelson died three and a half hours later.

The Battle of Trafalgar took place on 21 October 1805 when twenty-seven ships of Nelson's fleet defeated thirty-three French and Spanish ships. This effectively prevented any further plans by Napoleon for invading Great Britain. An invasion with his 'National Flotilla' had previously been called off as Napoleon could not wrest control of the English Channel from the British whose blockade had been successful.

Nelson's actions at Trafalgar gave him a knighthood at a time when he was due to be promoted to vice-admiral. The suppression of the Spanish in this action allowed Jervis to send Nelson back into the Mediterranean. Here, in August 1798, he was in command of a fleet that did terrible damage to a French fleet that was on the way to invade Egypt as a strategy to challenge the British in India. Egypt was an important staging point. The action was to stop Napoleon's plans for Egypt. His army was stranded and had no alternative to surrender. India was safe.

As to the monument, some say that it was designed by architect Robert Burn in the form of an upturned telescope – a fanciful opinion, in my view. Before this, a design

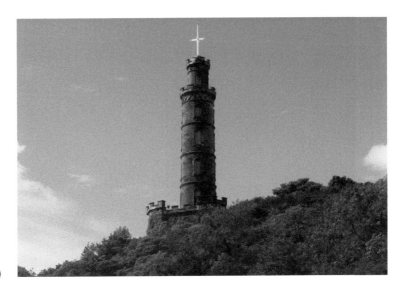

Nelson's
Monument,
Calton Hill.
(Michael Meighan)

had been sought from Alexander Nasmyth but his pagoda-style idea was too expensive. The concept of a castellated telescope stuck in a square box was the answer. The square box at the bottom did have a practical use as a rest for sailors, a tearoom and then as accommodation for a caretaker. It took from 1807 to 1816 to complete the building. Burn had died in 1815 and the Custodian's house was completed by Thomas Bonnar.

Besides celebrating Nelson, the monument has, or had, a very practical use from 1853 when a 'time ball' was installed at the top of the tower. This allowed ships in the Firth of Forth to set their chronometers. The ball drops from the top of the mast just as Edinburgh's famous One o'clock gun sounds. Come to Edinburgh and while listening for the boom of the gun, look up to Calton Hill and you will see the ball dropping – it's true. Believe me.

The time ball was invented in 1829 by Royal Navy officer Captain Wauchope. In the same year, the ball was first dropped so that ships could hear it was one o'clock if there was fog.

By the way, the tower houses a great wee museum and you can also climb to the top to get a great view of Edinburgh.

Statue of Arthur Wellesley, 1st Duke of Wellington, Exchange Square, Glasgow

Another famous man associated with the Napoleonic Wars was Arthur Wellesley, 1st Duke of Wellington, whose statue graces the front of Glasgow's Gallery of Modern Art (GOMA) in Exchange Square.

Wellington was famous in many respects. A Dublin-born Irishman of the 'Protestant Ascendancy' in Ireland, Arthur Wellesley joined the army and through campaigns throughout Europe and India rose to general of the forces fighting during the Napoleonic Wars. He was made a duke in 1814 and in 1815 he commanded the army that defeated

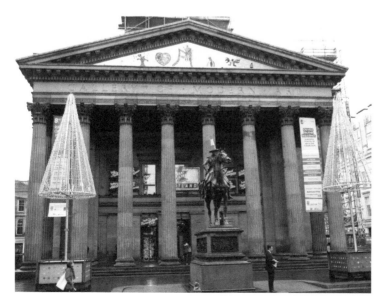

The Duke of Wellington on Copenhagen, Exchange Square, Glasgow. (Michael Meighan)

Napoleon at the Battle of Waterloo. The battle marked the end of the Napoleonic Wars and cemented Wellington's place as one of the greatest military commanders of all time.

In 1844, this prestigious location on Queen Street was considered appropriate for the new statue of Arthur Wellesley, sculpted by Italian Carlo Marochetti. But the building behind was not always GOMA.

The wealth created by Glasgow's tobacco merchants is well illustrated by the houses in which they lived. None was so ostentatious as William Cunninghame's mansion in Royal Exchange Square. This was originally on Cow Lane, which Cunninghame renamed Queen Street in honour of Charlotte, the wife of George III.

On William Cunninghame's retiral the building was used for a number of functions including Glasgow's first telephone exchange. In 1949 the building was taken over by Glasgow Corporation and it housed Stirling's Library until 1996 when it became the Gallery of Modern Art – GOMA.

I don't know when it became a custom to cap Wellington with a traffic cone but it has now become an established Glasgow icon even though 'the powers' have tried to stop it for 'health and safety reasons'. It was apparently costing around £10,000 a year to remove the cones, so Glasgow City Council proposed to restore the statue while doubling the height of the plinth to deter coners. Facebook campaign 'Keep the Cone' attracted over 10,000 petitioners and the plans were dropped. Among the reasons given were that Glaswegians hate being told what to do and that they were highly unlikely to let height stop them. It was decided to let the cone remain and it is probably safer in the long term. A more recent controversy arose recently when the cone disappeared for a short time. According to Glasgow Council, 'It wisnae us'.

In 2014, Wellington was given a Golden Cone in recognition of Glasgow's successful hosting of the Commonwealth Games. Later that year he was also given a 'Yes' cone as

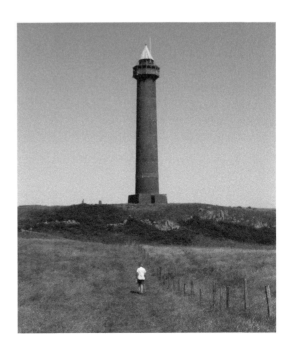

This huge and magnificent monument to the Battle of Waterloo is at Ancrum in the Borders. (Michael Meighan)

well as a Scottish Saltire in support of the campaign for Scottish Independence. It is easy to see that if such blatant partisan use persists then no doubt the council would be likely to resurrect moves to put the statue off limits. In the meantime, the cones remain to confuse and enchant the tourist.

This statue of Wellington is only one of many statues that you will find throughout Glasgow, particularly in our squares and parks as well as on public and private buildings. I invite you to take a stroll through Kelvingrove Park, George Square and along our streets, but do look up and you will see a wealth of sculptures, a living museum of the work of our great sculptors such as the Mossmans, father and sons.

The Scottish National War Memorial, Edinburgh Castle and the First World War, 1914–18

Edinburgh Castle is the repository of our national consciousness and of our own Scottish crown jewels, the Honours of Scotland, which include the Sceptre and Sword of State of Scotland. These items, unused and almost forgotten since they were put away following the Act of Union, were rediscovered by a group of antiquarians including Sir Walter Scott and Sir Henry Jardine. They are now on display in the Crown Room of the castle along with the Stone of Destiny returned to Scotland in 1996.

These items are of undoubted importance in preserving our historical and political identity. But just as important in preserving our history and heritage is the Scottish National War Memorial, a separate building within the walls of the castle.

The First World War was supposed to be the 'War to end all wars'. We know that is not true as war has touched us again and again and again.

The First War is recognised as one of the deadliest conflicts in history, with an estimated nine million fighting personnel and seven million civilian deaths as a direct result of the conflict. Almost 150,000 of these people were Scots. While Scotland had a population a tenth of the size of the United Kingdom's, it suffered one in five deaths in the conflict.

A memorial to the dead was opened by the Prince of Wales in 1927 and here are the Rolls of Honour of Scots servicemen and women from all the armed services, the Dominions, Merchant

The Scottish National War Memorial, Edinburgh Castle. (Michael Meighan Collection)

Right: Families of those who died in the First World War also received a memorial plaque commemorating a family member who died in the war. As a young boy in Glasgow I remember these hanging on kitchen walls. (Michael Meighan)

Below: *The Call.* A young soldier looks up to Edinburgh Castle from Princes Street. The memorial is a poignant tribute to the Scots-Americans who died in the conflict. (Michael Meighan)

Navy, Women's Services and Nursing Services as well as civilian casualties of all wars since 1914. My own grandfather, Hugh Meighan, is remembered there. He was a private in 2nd Battalion of the Cameronians (Scottish Rifles). He died on 12 March 1915 at the Battle of Neuve Chapelle and along with many others of his comrades is buried in the Estaires Communal Cemetery near Armentières in northern France. I was able to find his mention in the physical rolls but you can now search online on the Scottish National War Memorial website.

The war memorial was designed by pre-eminent Edinburgh architect Sir Robert Lorimer. He reused some of the barracks blocks to create three elements – a hall of honours, a national shrine and a roll of honours. While the castle is iconic, the memorial is classed as one of Scotland's most important buildings. The artwork was completed by several artists and craftspeople. Among these are the seven windows of the shrine designed by Scotland's favourite stained-glass artist Douglas Strachan. Alice Meredith-Williams provided sculptures of Knowledge and Truth and Thomas Hadden provided bronze gates.

The Quintinshill Rail Disaster, May 1915

It was May 1915. The First War was still its early stages. It wasn't 'over by Christmas' as expected.

At this lonely spot near Gretna, at 6.45 a.m., a troop train heading from Larbert to Liverpool collided head-on with a stationary local train. Just less than two minutes later, a northbound sleeping car express ran into the wreckage. The combined collision resulted in what is still Great Britain's worst ever rail disaster and to this day it is still mired in controversy.

Over 200 people were killed that day, the majority of these volunteer soldiers on their way to fight in Gallipoli. They were mostly from the 7th Battalion of the Royal Scots, raised in Leith. They were heading to the war, little knowing that half of their number were to die in a disaster every bit as harrowing as the fate many of their comrades were to meet on the beaches of the Gallipoli peninsula in the Dardanelles strait.

A roll call of troops following the crash showed that only half of the troops on the train had survived. An accurate figure for those who died was never established but the announced figure was 227,215 of whom were soldiers. The dead included nine passengers and three railway staff. Strangely not included in the final figures, were four other victims, thought to be children but never identified.

On the face of it, the reasons were quite straightforward: lack of attention, ignoring procedures and incompetence. However, the accident is still mired in controversy, with subsequent research pointing to whitewash and cover-up to protect the reputation of the

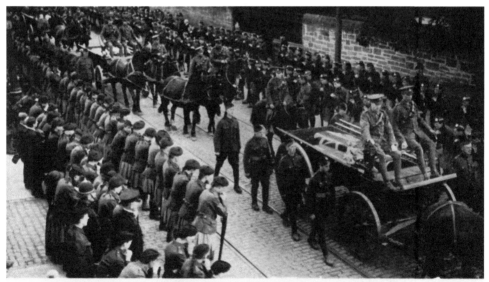

FUNERAL OF 100 VICTIMS OF THE GRETNA GREEN RAILWAY DISASTER AT LEITH WITH MILITARY HONOURS.
The long line of transport waggons containing the coffins passing through the town to the cemetery.

Quintinshill funeral parade in Leith. The reverse of this postcard reads, 'Got your letter yesterday. Our heavy battery left for France today. We are expected to leave in 3 weeks. A good many are away at Aldershor drawing ammunition. Yours sincerely, Jim.' (Michael Meighan Collection)

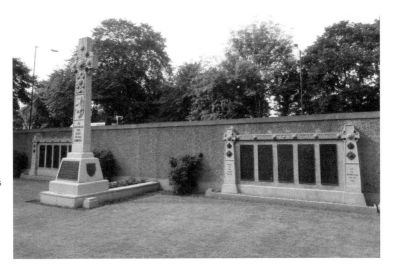

The soldiers were interred in a mass grave in Edinburgh's North Leith Rosebank Cemetery where an annual service is still held. (Michael Meighan)

Caledonian Railway Company and to disguise how bad troop transport was at the time. The fault was pinned squarely on two signalmen: James Tinsley and George Meakin.

The Quintinshill signal box was on a lonely stretch of what was then the Caledonian main line joining Glasgow and Carlisle. The only reason for the signal box was to control loops. These were necessary to allow faster trains such as the sleeper express to pass slower or local trains, which had less priority.

Perhaps one of the best books, one that is well researched, is *The Quintinshill Conspiracy* by Jack Richards and Adrian Searle. They contend that the signalmen, who had no doubt flouted a number of rules, nevertheless shouldered all of the blame for the crash. It was alleged that this was to protect the reputation of the Caledonian Railway Company as well as morale at this time, early on in the First World War. In fact the only newspaper to flout an apparent embargo was the *Dumfries and Galloway Standard and Advertiser* whose headline on 28 May 1915 read, 'The most calamitous railway disaster in the history of Great Britain, both in overwhelming magnitude and the horror of the scenes that followed, occurred on Saturday morning on the Caledonian railway, half a mile north of Gretna Junction.'

'La Pasionaria': Scotland and the Spanish Civil War

There were many other wars that Scots fought in, including Crimea, Afghanistan and the South African Wars. You could call these 'official wars'. There was one other war in which Scots fought in as volunteers and that was the Spanish Civil War.

The civil war involved Spanish Republicans against a confederation of right wing-military, Catholics and Monarchists who wished to overthrow the legitimate left-wing government.

The intransigence of Great Britain, France and America inflamed anti-Fascists in those countries and led to the formation of the International Brigades: fighters and non-combatants from many countries who arrived in Spain to fight for the democratic Republic. Estimates were as high as 50,000 over the period, with another 10,000 in non-combatant roles such as ambulance driving.

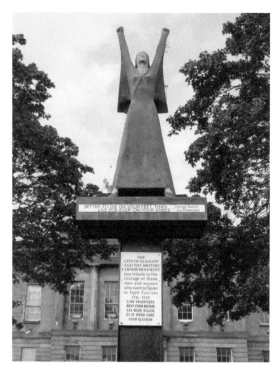

La Pasionaria, Custom House Quay, Glasgow. (Michael Meighan)

Of the 2,000 Britons involved in the war, around 500 of them were from Scotland. 134 lost their lives. Sixty-five of these were from Glasgow, so it is no surprise to find a memorial to them in a city so steeped in Socialist history. Most of those leaving Scotland knew that if Fascism was not stopped in Spain then its spread would not continue. How right they were.

The memorial is on the banks of the River Clyde at Custom House Quay in the centre of Glasgow. It is of La Pasionaria, or Dolores Ibárruri, a Spanish politician known for her passionate and rousing speeches on behalf of the Republic.

The Commando Memorial, Spean Bridge, Lochaber, and the Second World War

It is one of the Highlands and Islands most iconic images and one visited by thousands on their way north as they pass from Fort William to Spean Bridge and along the Great Glen towards Inverness. Quite often the visit is accidental as this landmark is so striking and placed on such a prominent position that stopping to have a look is almost compulsory. The memorial sits just outside Spean Bridge Village and from here can be seen the glorious Ben Nevis and Aonach Mòr mountains.

The statue commemorates the role of British Commandos during the Second World War. While those Commandos fought in many theatres of war, it is entirely consistent that they are remembered here, for it was in these mountains that they were trained before being sent out on some of the most hazardous missions of the war. The training depot was established here at Achnacarry Castle in 1942, one of many buildings and estates taken over by the War Office while making the Highlands and Islands a 'Restricted Area'.

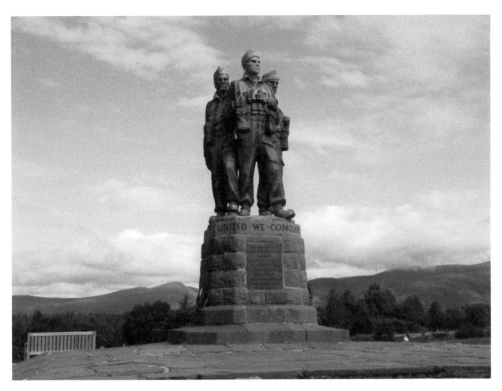

'United we conquer'. 'In memory of the officers and men of the Commandos who died in the Second World War 1939 – 1945. This country was their training ground.' (Michael Meighan)

The British Commandos were set up on the instructions of Winston Churchill, in June 1940. This was following the disastrous Battle of France in which the British Expeditionary Force (BEF) had been evacuated from Dunkirk. The idea was for a fighting force that could attack the Germans swiftly along the occupied coasts. While the force was initially made up of volunteers from the army, it eventually recruited from all services and from volunteers from the services of the occupied territories. The Commandos would instigate a reign of terror down the occupied coast while Britain prepared for invasion.

The statue was the work of Wick-born sculptor Scott Sutherland whose training included Gray's School of Art and Edinburgh School of Art. He returned to the latter where he taught sculpture from 1947.

The memorial was cast by HH Martyn and Co. and unveiled by the Queen Mother in September 1952.

I have chosen this famous monument to represent the thousands of local monuments throughout Scotland as there is not a village, town or area that does not have a memorial to the young people who went off to war. Some of these are simple plaques and some are elaborate sculptures. All are worth a look and I urge you to stop in the railway station, or in the town square or the local park, and look for the names of those who are remembered.

4. Marine Tragedies

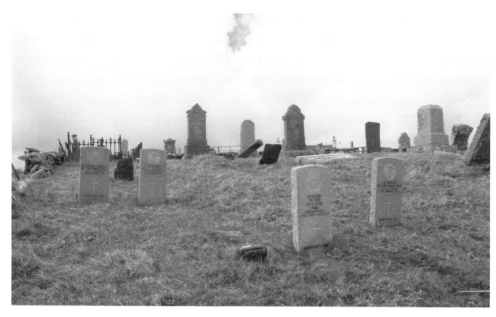

'A Royal Marine of the Great War HMS Viknor' on a stone in a cemetery in the Western Isles. (Michael Meighan)

The seas have been central to the safety and survival of the British Isles, but they are also dangerous and unpredictable. The danger has been demonstrated in the numerous, if not constant, sinkings around our coasts.

Wherever you travel to on our shores you can visit cemeteries where interred seafarers from liners, warships and fishing boats lie. Some of these graves sadly just say 'a sailor'. In many cemeteries throughout Great Britain and beyond all graves of service personnel are looked after lovingly by the War Graves Commission. You will see the sign on the cemetery gate.

HMS *Natal*, Cromarty, 1915

The Cromarty Firth is probably best known these days for porpoises and seals, and often for the oil rigs in storage or maintenance. However, few know that the Cromarty Firth was once a major base for the Royal Navy's Home Fleet and the scene of the Invergordon Naval Mutiny of 1931. It was also famous, in 1915, for a very different reason, for it was the scene of a major naval disaster: the sinking of the HMS *Natal*.

HMS *Natal* was a Warrior Class armoured cruiser with the 2nd Cruiser Squadron of the Grand Fleet that sailed from Scapa Flow to the Cromarty Firth the week before Christmas.

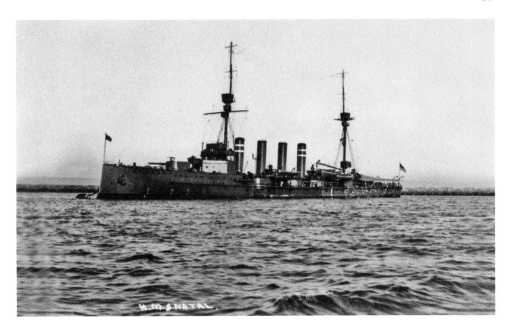

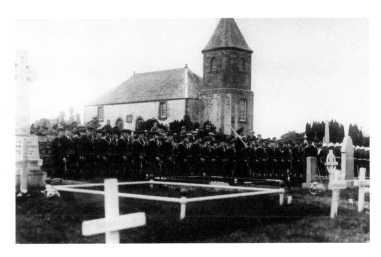

Above: HMS *Natal* armoured cruiser, 1907. (Michael Meighan Collection)

Right: A burial party is in attendance in the Free Church cemetery in Cromarty as some of the dead from the HMS *Natal* are buried. (Michael Meighan Collection)

On 30 December captain Eric Back was hosting a film show and officers' wives and children were aboard, as well as a number of local civilians. Around 3.30, without any warning, a series of explosions rent the rear of the ship apart and it sank immediately. 421 lives were lost, drowned or dead from exposure in the icy waters.

The ship could not be salvaged but parts of it were removed and it was further cleared in the 1970s as it was a danger to shipping. What remains is a designated war grave marked by a bouy.

Some of those who died are buried in cemeteries in Rosskeen and in Cromarty, graveyards on either side of the Cromarty Firth. Invergordon hosts the Natal Gardens where you can also see a plaque remembering the dead.

Eoropie Memorial, Eoropie Dunes, Ness, Isle of Lewis

We are an island race and we pay a high price for the security of our existence. Much of that high cost has been in defending our shores from invaders. Some of it has been in the winning of security for our families, in the search for fish for food.

There are many monuments all round our lands to those lost at sea while fishing but I have chosen one that I came across last year as I walked with friends round the northernmost coast of the Isle of Lewis in the Outer Hebrides. This is an isolated and rugged coast of high winds from the Atlantic where communities have challenged the sea for centuries, sometimes losing.

No doubt the weather had been grim for a while otherwise the crews would not have set out in such terrible conditions. However, the people had to be fed, so on 5 March 1885, two boats, the *Eathar 1* and *Eathar 2*, set out and it is best if we turn to *The Highland News* of Monday 16 March for an account:

> It occurred quite close to the shore in broad daylight, and in the presence of scores of men and women, who yet were perfectly powerless to render the slightest assistance owing to the terrible surf and strong under-current. One poor fellow, after all his comrades had been swept away, clung for dear life to one of the battered boats for over two hours, watched by those on shore. As each billow broke over him he was seen wiping the salt foam from his eyes, whilst gazing wistfully towards the well-known faces lining the beach. At last, he too, sank into the hungry deep. A desperate effort was made to launch a boat, but she was dashed back by the rolling waves against the rocks and broken, the crew being saved only with the greatest difficulty.

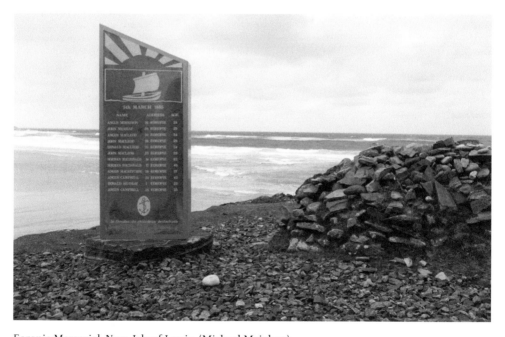

Eoropie Memorial, Ness, Isle of Lewis. (Michael Meighan)

Wild seas at the Butt of Lewis, now protected by the Butt of Lewis Lighthouse. (Michael Meighan)

The Ness crews left nine widows and twenty-two children, all now without support or the means of survival.

I wonder at the cruel circumstances that made people attach themselves to this way of life, for I discovered that this disaster at Eoropie was only one of several affecting the people of Ness in this most north-westerly community of Europe.

A boat from Skigersta was lost in 1835 when six men perished, six men from Fivepenny drowned in 1847 and in 1851 five were lost from Lionel. Further disasters resulted in a total of ninety-six men lost between 1835 and 1900 and a separate memorial to all of these has been erected above the port of Ness.

The Eoropie memorial is above the beach at the Eoropie Dunes Park below the village of Eoropie where the fragrance of burning peat fills the evening air. We got there as part of a walk round the Butt of Lewis, taking in the magnificent Butt of Lewis Lighthouse.

Piper Alpha Memorial, Aberdeen
In the 1960s a new harvest began; oil and natural gas had been discovered in the North Sea. The rewards from this were to be enormous but so apparently were the risks. In the rush to extract oil from these forbidding waters oil rigs and production platforms were quickly introduced using new, and sometimes untested, designs and technology.

The inevitable happened when, on 6 July 1988, the oil production platform Piper Alpha, 120 miles north-east of Aberdeen, suffered a gas leak. The resultant explosion and fire killed 167 including two crewmen of the rescue vessel *Sandhaven*. Sixty-one oil workers survived – thirty bodies were never recovered.

It is considered to be the costliest man-made disaster ever; it was certainly the worst offshore oil disaster in terms of lives lost. Besides the loss of life, the insured loss was 1.7 billion.

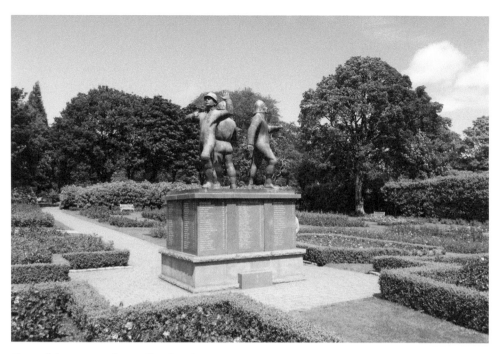

Piper Alpha memorial, Hazelhead Park, Aberdeen. (Michael Meighan)

Here, in Aberdeen, among the fragrance of over 11,000 roses, is a very special place for the people of the north-east and of the industry, and it is a place that you must visit. It represents not only those who died, but the survivors and all of those other who have died or who fought the elements in the search for oil.

This memorial to the Piper Alpha victims is in Aberdeen's Hazelhead Park, sculpted by Sue Jane Taylor. There is also a memorial chapel in Aberdeen's St Nicholas Kirk on Union Street. The oil workers who perished, or survived, came from throughout Scotland and beyond and are also remembered in their home towns. In Lanarkshire's Strathclyde Park there is a memorial to the six North Lanarkshire men who died in the disaster.

The Cullen Inquiry that followed the disaster blames faulty maintenance and inadequate safety procedures. 106 recommendations were made, which laid the foundations for a much safer environment for those risking their lives to bring oil and gas ashore.

5. Heroes of Literature and Culture

Robert Burns Mausoleum, Dumfries

It was seeing statues of Robert Burns in both Ballarat and Melbourne in Australia that made me realise the influence that the Scot has had throughout the world, and the influence of Robert Burns in particular. Is there any corner of the world where 'Auld Lang Syne' is not sung to welcome in the New Year? Is there anywhere where Scots have gathered where there is not a Burns Supper held to honour his memory?

To represent these many memorials I have chosen the one that marks his grave, in St Michael's churchyard in Dumfries, where a magnificent mausoleum holds his mortal remains and those of his wife, Jean Armour, and children.

There is absolutely no doubt that Robbie Burns, 'Scotland's Bard', has touched the life of the Scot more than any other in our country's cultural history. From the humblest of farming backgrounds, he achieved fame in his own lifetime and legend beyond. He left a huge legacy; not just his collection of poems, for he was also a collector of traditional songs and poems.

Robert Burns was born at Alloway in Ayrshire in 1759 into a tenant farming family. He was the eldest son of seven, of William Burnes and Agnes Broun, who took positive measures to ensure that their children benefitted from education, to the extent that they and their farming neighbours paid for a teacher and made full use of libraries as they could.

Burns was on the point of heading for a new life in the West Indies with Mary Campbell, whom he had met while living in Tarbolton to where his family had moved. It is thought

Robert Burns
Mausoleum,
Dumfries.
(Michael Meighan)

that they had secretly married by exchanging bibles. Unfortunately 'Highland Mary' contracted typhus while nursing her brother and died.

It was around this time that Burns' poetry began to be noticed. Using a subscription system, local printer John Wilson, produced them in what has come to be known as 'the Kilmarnock Edition', although Burns' title was 'Poems, Chiefly in the Scottish Dialect'.

The volume contained some of those that we have come to know and love including 'Twa Dugs', 'The Cotter's Saturday Night' and 'To a Mouse'.

Burns had only postponed his journey to Jamaica and was due to sail until he received a letter from an Edinburgh poet, Thomas Blacklock, who encouraged Burns to launch a second edition of his work. Burns set out for Edinburgh where he was warmly welcomed by Edinburgh's men of letters including Sir Walter Scott.

The new edition earned Burns £400 and cemented his success, as did his reception in Edinburgh where he was to make friends, and again, conquests.

He returned from Edinburgh to Dumfries where he took up again with Jean Armour. Her father had previously banned the marriage but was persuaded by Burns' new-found prospects. Robbie took a lease on Ellisland Farm where he settled down to family life. He also took a second occupation to supplement the meagre income from the farm – as an excise officer, travelling the country. His duties included the stamping of leather, gauging malt vats, monitoring candle making and granting licences for the movement of spirits. In those days trade, particularly distillation, was tightly controlled and many products had individual taxes. It was the duty of the exciseman to control and stamp these.

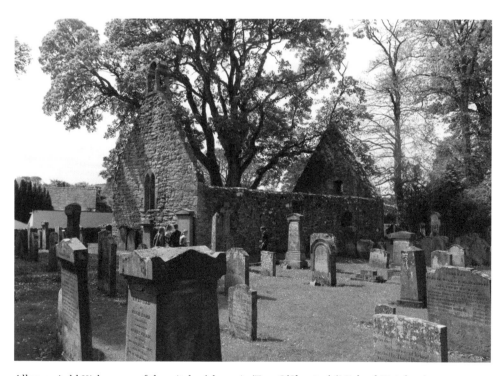

Alloway Auld Kirk, scene of the witches' dance in 'Tam O'Shanter'. (Michael Meighan)

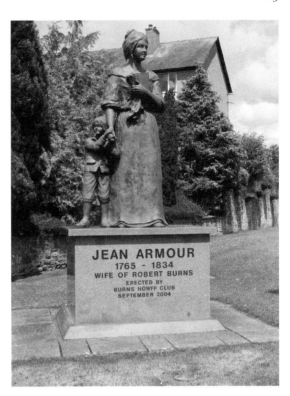

Statue of Jean Armour in Dumfries.
(Michael Meighan)

Burns died at home in Dumfries aged thirty-seven, from heart trouble and rheumatism. Burns' home is still there in Dumfries and you will be both surprised and delighted to find that it is filled with his and his family's possessions, some of them having been reunited with the house over time. The guide told us that one thing that was missing was the Burns' bed. It may have gone to one of the three children who survived to adulthood on the death of Jean Armour in 1834. She had outlived Burns by thirty-eight years.

In 1813, prominent Dumfries businessmen launched an appeal for funds to build a mausoleum to replace his original burial plot. Dorothy and William Wordsworth visited the graveyard in 1803 and they had difficulty in finding it.

It was felt strongly, wider than just Dumfries, that Burns merited a much more dignified place of burial and memorial. It is indeed a light and airy tomb with a good view of the stones, dedicated to Burns and his wife Jean Armour and their children. I was surprised that it is painted white and is quite stunning with it.

If you wish to visit more Burns monuments then there is no shortage, starting with the Burns Memorial in Alloway near the cottage where he was born. There are monuments throughout the world, particularly in America and the Commonwealth where they have been erected by numerous Burns clubs and Caledonian Societies.

It is Burns' understanding of humanity and nature that endeared him to all Scots, whether at home or abroad. It is no wonder also that he came to be respected beyond the Scottish diaspora, in such unlikely places as Russia. His message of human goodness was, and is, truly international.

Burns' poetry has also ensured that each New Year is celebrated throughout the world just as we do in Scotland with Auld Lang Syne, Burns' poem derived from traditional sources.

There is also one poem that represents my own views and I am convinced has endeared my own country to Burns, and that is a poem that represents our egalitarian views:

'A Man's a man for a' that' (1795)

Is there for honest Poverty
That hings his head, an' a' that;
The coward slave-we pass him by,
We dare be poor for a' that!
For a' that, an' a' that.
Our toils obscure an' a' that,
The rank is but the guinea's stamp,
The Man's the gowd for a' that.

The Scott Monument, Princes Street, Edinburgh

Sir Walter Scott was a highly influential and respected Scottish novelist whose works were read throughout the world in the nineteenth century. He was our first best-selling international author with many of his works still being read and considered classics. The Waverley novels include *Waverley, Rob Roy, Ivanhoe* and the *Heart of Midlothian. Waverley* is also considered to be the first historical novel.

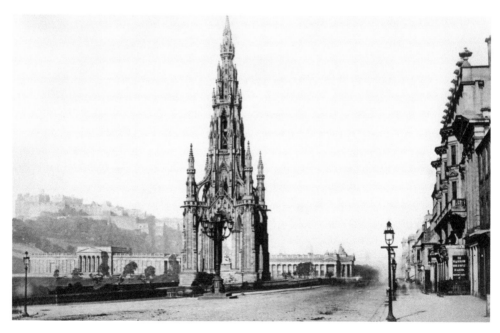

Princes Street and the Scott Monument. (Michael Meighan)

The names of many of Scott's characters were given to the locomotives of the North British Railway and of course, Waverley became the name of the station and is also remembered in the last ocean-going paddle steamer, PS *Waverley*, based on the River Clyde.

After Scott died in 1832, a competition to design a memorial to him was won by George Meikle Kemp. The finished memorial included a statue of Scott between the four columns. The white Carrara marble figure shows Scott with a quill pen and paper and his dog Maida at his side. Those who have climbed the inside stairway of the monument will know the enormity of this Gothic monument to just one man.

I say one man, but in fact the monument also includes memorials to other famous Scots including Robert Fergusson, Allan Ramsay and Lord Byron. There are also sixty-four characters from his books and poems: Mary, Queen of Scots appears in *The Abbot* and Rob Roy Macgregor appears in *Rob Roy*. Both are represented on the monument.

Sir Walter Scott is also remembered for a very different reason. Scott helped to reinvent the Scottish image by telling the Prince Regent, at a dinner, that he should visit Scotland when he became king. During his subsequent 1822 visit, King George IV wore full Highland regalia. The visit, filled with Highland and Celtic pageantry, is credited with making the kilt and tartan an integral part of Scotland's national identity.

In 1818, Walter Scott rediscovered the crown jewels, thought long lost, in a locked chest in Edinburgh Castle where they had been stored and almost forgotten. In a letter he described the discovery:

> The extreme solemnity of opening sealed doors of oak and iron, and finally breaking open a chest which had been shut since 7th March 1707, about a hundred and eleven years, gave a sort of interest to our researches, which I can hardly express to you, and it would be very difficult to describe the intense eagerness with which we watched the rising of the lid of the chest ...

He noted that 'the sword and sceptre showed marks of hard usage'. The jewels were then placed on display, where they still remain to this day. The king awarded him a baronetcy for his discovery.

Scott built a mansion, Abbotsford, in the Scottish Borders, where his wife Charlotte would grumble at the numbers of unexpected visitors. The building of Abbotsford nearly bankrupted him. The sumptuous building, with its huge library of more than 9,000 books and vast collection of armaments, therefore had to be put in trust, forcing Sir Walter to write himself out of financial trouble.

In 1826, he lobbied parliament to allow Scotland to retain the right to print its own banknotes. Sir Walter Scott now has pride of place on the front of all notes printed by the Bank of Scotland.

Coming home from an Italian holiday that had been prescribed for the good of his health, Scott suffered the stroke that was to kill him! As a result he died, aged sixty-one, in September 1832. He was buried at Dryburgh Abbey, a beautiful ruin that is well worth a visit.

Abbotsford, near Galashiels in the Scottish Borders, is the former home of Sir Walter Scott and it is a fantastic place to visit. (Michael Meighan)

Robert Fergusson Memorial, High Street, Edinburgh

The poet Robert Fergusson, who appears on the Scott Monument, can also be seen striding down the High Street outside the Canongate Kirkyard where he was buried in an unmarked grave. He died in illness and penury and this so distressed Robert Burns that he paid for a memorial headstone of his own design.

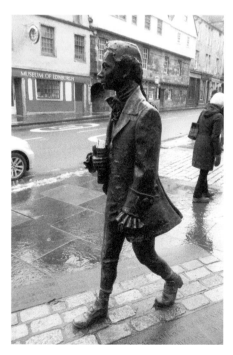

Robert Fergusson on Edinburgh's High Street. Visit his grave in the churchyard behind. The gravestone was funded by Robert Burns. (Michael Meighan)

Sir Arthur Conan Doyle and the Sherlock Holmes Statue

If you are staying in Edinburgh then you must stop at the memorial to one of our favourite writers. It is quite appropriate that he is represented at the top of Leith Walk by his most famous character, Sherlock Holmes. For just across the road from this bronze work is Picardy Place, the birthplace of Arthur Conan Doyle.

If you wish you may stop for a while in The Conan Doyle pub close by where you can investigate a wealth of information on Doyle, Sherlock Holmes and Dr Watson. Sherlock Holmes was of course the most famous 'consulting detective' in literary fiction.

Arthur Conan Doyle was born in Edinburgh and studied medicine there. He practised in various places in England before becoming a doctor on a Greenland whaler, the *Hope*, of Peterhead in 1880 and then worked for a spell as a ship's surgeon on the SS *Mayumba*, sailing to the West African coast.

Thereafter he had varying success in practising medicine and while waiting for patients he returned to writing, having had some small works published previously.

While he is best known for Sherlock Holmes, his historical and other works received acclaim, particularly the Professor Challenger series.

He was also a reformer and took an interest in a famous Glasgow murder case, that of Oscar Slater who was accused of killing an eighty-two-year-old woman in 1908. Doyle thought that there were inconsistencies in the evidence. This led him to pay for a defence leading to Slater's release after a successful appeal in 1928.

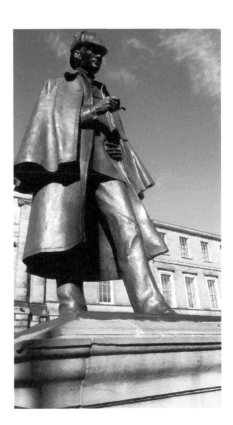

Sherlock Holmes statue at the top of Leith Walk, Edinburgh. (Michael Meighan)

Alexander Selkirk's cottage and Robinson Crusoe statue. (Michael Meighan Collection)

Alexander Selkirk's Cottage and Robinson Crusoe Statue

Born in Largo in Fife, Alexander Selkirk was a privateer and Royal Navy officer who spent over four years as a castaway on a deserted island in the South Pacific. His experiences gave us *Robinson Crusoe*.

If you ever take a walk on the Fife Coastal Path then you will pass through Lower Largo and can watch out for the cottage where he was brought up, his father being a tanner and shoemaker.

Desperate Dan in Dundee

I have given you only a few of Scotland's literary heroes as I don't have a space for many others. However I do want to pay tribute to those comic characters which have brought fun and joy to generations of young Scots, and you can see a statue to a couple of them in Dundee.

When you visit the amazing new V&A Museum in Dundee and Captain Scott's ship the RRS *Discovery* then take a walk up to the Caird Hall where you will see Desperate Dan and his pals. (Michael Meighan)

Dundee is the home of 'jam, jute and journalism', the latter mostly meaning the D. C. Thompson publishing company. Among its famous publications are *The Sunday Post*, *The Beano*, *The Dandy*, *Jackie* and *Commando* comics.

In Dundee you will find a lovely group of Desperate Dan, Dawg and Minnie the Minx. This is only a representative group for among the others are Dennis the Menace, Black Bob, The Broons and of course 'Oor Wullie, your Wullie, a'body's Wullie.

Greyfriars Bobby, Edinburgh

It is as iconic as Edinburgh Castle and while the castle dominates the city and the Lothians with its massive size, the diminutive memorial to Bobby sits quietly where George IV Bridge meets Candlemaker Row, above the Cowgate in the Old Town.

I wonder if you could compare the numbers of visitors to both but given the groups round the statue as I pass on the bus, there must be a favourable comparison. But I do wish they wouldn't rub the wee doggy's nose 'for luck' as this is causing erosion. It was never a superstition; it was invented by visitor guides to add a little fun to the occasion.

It is said that Bobby, a Skye terrier, was owned by Edinburgh nightwatchman John Gray. When John died, Bobby looked after his master's grave and remained there until his death in 1872. It is said that the then Lord Provost, Sir William Chambers, paid for a licence for Bobby and gave the dog a collar that is now in the Museum of Edinburgh on the High Street.

Greyfriars Bobby on Edinburgh's George IV Bridge.

Whatever the reality, the story was turned into a novel in 1912 by American Eleanor Atkinson. She embellished it, making John Gray a shepherd. However, a year later Lady Angela Burdett-Coutts, granddaughter of the famous banker Coutts, heard of Bobby's story and was moved. She paid for the memorial to Bobby. Burdett-Coutts became one of Great Britain's wealthiest women when she inherited her grandfather's fortune and estates.

The statue was sculpted in bronze in 1872 by William Brodie, whose other works include statues of Walter Scott on the Scott Monument in Princes Street. It is mounted on a 3-foot-high polished Westmoreland granite column and includes a drinking fountain at ground level as well as the arms of Baroness Coutts and the City of Edinburgh.

This is probably Scotland's smallest listed building. It became Category A in 1977. Irrespective, it had suffered from years of neglect until it was restored in 1985.

Robert Louis Stevenson Memorial, Colinton Dell, Edinburgh

Another of our great storytellers was Robert Louis Stevenson who gave us *Kidnapped*, *Catriona* and *The Strange Case of Dr Jekyll and Mr Hyde*.

Robert was brought up in Edinburgh where his father was the famous lighthouse engineer Thomas Stevenson. For much of his life he suffered from a bronchial complaint. This did not prevent him being a prodigious traveller and writer. Much of his travel was to find somewhere suited to his ailing condition. This took him eventually to the island of Samoa where he died, probably of a cerebral haemorrhage. It was here that he penned his own requiem that was carved on his tomb:

> Under the wide and starry sky,
> Dig the grave and let me lie.
> Glad did I live and gladly die,
> And I laid me down with a will.

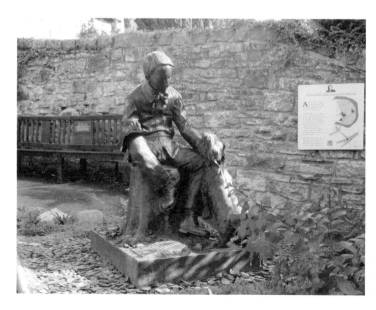

Robert Louis Stevenson as a boy with his Skye terrier 'Coolin' in Colinton village, Edinburgh. (Michael Meighan)

This be the verse you grave for me:
Here he lies where he longed to be;
Home is the sailor, home from the sea,
And the hunter home from the hill.

The Writers' Museum off the High Street in Edinburgh has a room dedicated to Robert Louis Stevenson and in Colinton Village you will find a statue of him as a boy with his Skye terrier 'Coolin'. This lovely work was sculpted by Alan Herriot. It is set in a little Stevenson poetry walk. Stevenson's maternal grandfather, Dr Lewis Balfour, was a minister at the church there and Stevenson often visited.

In Costorphine Road in Edinburgh you will also find a memorial featuring Alan Breck Stewart and David Balfour, characters from *Kidnapped*. This is the spot where Stevenson described them as parting.

Catherine Sinclair Memorial, Edinburgh

A bit earlier than Robert Louis Stevenson was Catherine Sinclair, a Scottish novelist and writer of children's stories. While she was popular in her lifetime, she has been a bit neglected – like her statue in North Charlotte Street, Edinburgh.

Besides her literary activities Catherine was a philanthropist who dedicated herself to charitable activities that included establishing cooking stations and drinking fountains.

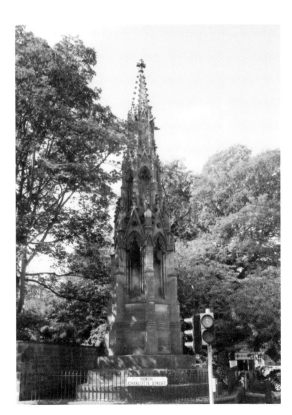

Catherine Sinclair memorial, Edinburgh.
(Michael Meighan)

6. Scientific Advancement and Exploration

David Douglas Memorial, Scone, Perthshire

While there are only a few remnants of Scotland's ancient Caledonian forests, we are indebted to David Douglas, whose short life helped to sculpt rural Scotland as it is now, for it was he that brought and named the Douglas-fir to this country.

David Douglas was born in Scone in 1799 where he was apprenticed as a gardener to the Earl of Mansfield at Scone Palace. The staff of Scone Palace would have been large

This monument to the life of David Douglas was erected in 1847 by 'The lovers of Botany in Europe'. (Michael Meighan)

and many of the residents of Scone would have lived and worked there. In fact, there are two Scones, Old and New, the earl having cleared his land of most of the Old and rebuilt higher up the valley to create New Scone. The clearance of estates for improvement was a common feature of rural life back then.

After seven years at the palace David moved on to Valleyfield Estate in Fife and then to the Botanical Gardens of Glasgow University. He impressed the Director of Gardens and Botany Professor William Jackson Hooker, who recommended him to the Royal Horticultural Society of London to where he travelled in 1823.

David made three trips to North America in the 1820s and 1830s from British Columbia to California. He travelled widely along the Columbia, Williamette and Fraser rivers, sending the plants back to Great Britain. During his time in America he observed the culture of the Pacific Northwest tribes and how they used plants in food, medicine and clothing.

David suffered a tragic end in the Sandwich Islands, now called Hawaii, in July 1834. He died on the north-east side of the dormant volcano Mauna Kea, the highest mountain in the Pacific, when he was crossing the island to reach Hilo, on the Big Island of Hawaii. The story was that he had fallen into a pit that was used to trap animals, and was gored to death by a bullock. That same year, a plaque was unveiled to his memory near the spot where he died. Douglas-firs also mark the spot.

Around eighty species of plants are named after him while he identified hundreds of plants, sending over 200 back to Great Britain.

The Douglas-fir is often named with a hyphen as here because it is not a true fir, not being a member of the genus Abies, or Fir. The true name is the pseudotsuga menziesii and is named after an earlier Scottish botanist who first documented the tree on Vancouver Island in 1791, Archibald Menzies. Archibald Menzies hailed from Weem, near Aberfeldy.

If you visit the nearby Scone Palace then you will see some fine examples of the Douglas-fir in the Pinetum, which was laid out in 1848. These were raised from seeds sent back to Scone Palace where David's father John was head stonemason. He must have been very proud.

William Thomson, Lord Kelvin, 1824–1907

It was William Thomson who turned a very small 'natural philosophy' department at Glasgow University into a large and effective department teaching physics. He was also instrumental in turning inventions into practicalities, taking out around seventy patents.

Born in Belfast, he was to move to Glasgow at an early age when his mathematician father took up a post at Glasgow University. He was well provided for and his father ensured an excellent start to his career with introductions allowing him to study at Peterhouse College, Cambridge where he excelled in all subjects including sports. However his main interests were in physics, particularly in the fields of thermodynamics and electricity.

Besides founding a laboratory at Glasgow University and being the first to teach physics in the lab, he was responsible for a wide range of innovations and inventions. He invented a tide predictor and using this produced a theory of revolution of the earth's poles, this being confirmed with computers in the 1950s.

Lord Kelvin in Kelvingrove Park, Glasgow. Absolute zero at 0 Kelvin = −273.15 degrees Celsius. (Michael Meighan)

His work on the Atlantic cable was momentous. He theorised that the quality of the cable was fundamental to the success of electricity flow. He successfully designed recording equipment which could be used over the huge lengths of the cables. He introduced the absolute scale of temperature, now measured in 'Kelvins'. He was a prodigious researcher and produced around 600 papers. He successfully introduced a range of nautical instruments including depth sounders, compasses, sextants and chronometers.

His work has been extremely important to science and to Scotland and reflects why Scotland has been so successful in the application of scientific discovery. He was an entrepreneur who could see practical application in his work and through this contributed considerably to Britain's ability to defend itself through two world wars.

James Watt Statue, George Square, Glasgow

James Watt welcomes you to George Square in Glasgow. That's Sir Walter Scott on the Column. Other memorials include The Cenotaph, Robert Burns and Robert Peel.

It is well worth a visit, as is the People's Palace and the restored Doulton Fountain. A stone in Glasgow Green also commemorates the place where James Watt was said to have come up with his ideas for a condenser for the steam engine, so starting the age of steam.

James Watt is undoubtedly one of Glasgow's heroes and there is a well-established myth that he invented the steam engine while strolling by the banks of the Clyde at Glasgow Green. First of all, he didn't invent the steam engine and whether he did what he did while on Glasgow Green is probably a wee story.

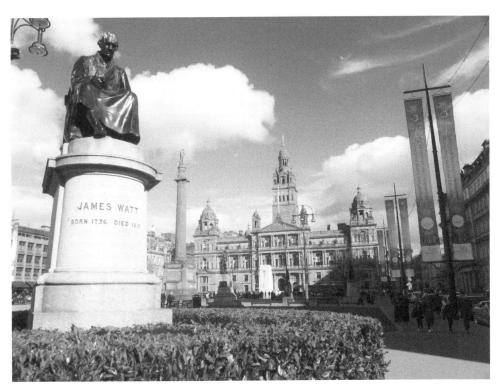

James Watt welcomes you to George Square in Glasgow. That's Sir Walter Scott on the column. Other memorials include the Cenotaph, Robert Burns and Robert Peel. (Michael Meighan)

Anyway, the truth is that he worked from 1756 as an instrument maker at the university including building some of the instruments used by the famous Professor of Medicine Joseph Black, discoverer of carbon dioxide.

One of his projects, for Professor John Anderson at Glasgow University, was the repair of a model of Thomas Newcomen's steam engine. The engine, which appeared around 1712, had been used primarily for lifting water from mines. The beam engine, powered by Newcomen's engine, was only cost-effective where coal was abundant, as a lot of energy was required to heat the main cylinder, which was cooled as the steam condensed. Where mining was for other than coal, such as tin in Cornwall, the cost severely raised the overheads of production.

It was Watt who realised that a great deal of energy was wasted in cooling and reheating the cylinder. He devised a separate condenser that vastly improved the efficiency of the engine. He also made other improvements such as doubling the action of the pistons using both up and down strokes for power. The royalties for use of their machine and improvements made Watt and his partner Matthew Boulton rich men.

Lachlan Macquarie's Mausoleum, Isle of Mull

Australia was discovered by western civilisation in 1770 by Captain James Cook on the HMS *Endeavour* when he landed at Botany Bay. Thereafter, while claimed by the Crown,

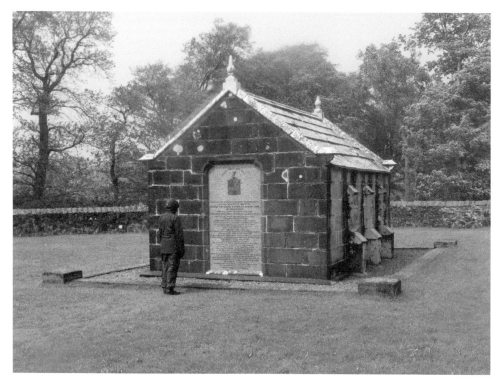

Lachlan Macquarie's Mausoleum – 'The Father of Australia'. (Michael Meighan)

it was left very much ignored until Admiral Arthur Phillips became the first Governor of New South Wales and in 1787 established the first penal colony that was eventually to become the city of Sydney.

The beginnings of the colonisation were riven by corruption, incompetence and self-interest. There was resistance from the free settlers to freed convicts acquiring land and status. While Phillips had wanted to take tradesmen as well as the many petty criminals he was not allowed to do so.

Macquarie was born on the Island of Ulva, off the coast of Mull in the Inner Hebrides. At the age of fourteen he enlisted in the army, the 84th Regiment of Foot in 1777. The regiment were off to America to defend Great Britain's interests during the American War of Independence. With six years' service from Nova Scotia to Jamaica he returned to Scotland as a lieutenant.

After some time back in Scotland when his regiment was disbanded, he embarked for India at the age of twenty-six, where he met and married Jane Jarvis. Following her death from tuberculosis he returned to Mull where he met Elizabeth Campbell. It was at this point that he was offered the position of Governor of New South Wales.

You can hardly visit New South Wales and Sydney without being fully aware of the influence of Lachlan Macquarie. There is the Macquarie University, the Macquarie River, the Macquarie Bank, Macquarie Place, and Macquarie Streets throughout New South Wales.

It is a long way from Ulva to Sydney. Until I visited Sydney, I had no idea that Macquarie and his wife Elizabeth were so important to the development of Australia. It was Macquarie who was instrumental in allowing ex-convicts to purchase and develop land.

In 1948, the original mausoleum was in a state of neglect but the land on which it stands was gifted by a neighbouring landowner, Lady Yarborough, to the people of New South Wales. It is now looked after by The National Trust of Australia. The mausoleum, of sandstone with marble panels at either end, holds the remains of Lachlan and Elizabeth Macquarie and their children Lachlan and Jane, the latter of whom died in infancy.

7. Natural and Man-made Disasters

Cheapside Street Fire Memorial

Fires were very common in the centre of Glasgow in the 1950s and 1960s. We had seen St Patrick's Girls' School on fire as well as the famous St Andrew's Halls. These were enormous. 'Lum' fires (chimneys) and chip-pan fires were common, particularly on a Friday.

One fire that stays with me and which was Glasgow's largest peacetime fire was the Cheapside Street Fire, very close to my home.

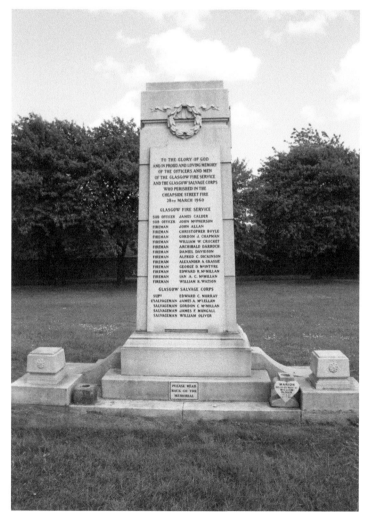

The Cheapside Street Fire memorial in the Glasgow Necropolis. (Courtesy of Stephencdickson via Wikimedia Commons)

To begin with, the fire was within a whisky bond (warehouse) owned by Arbuckle Smith and Co. There was not much to see, just the plumes of dark smoke, the smell of burning, the fire bells and the firemen running around, attaching hoses. In those days you could get very close to a fire and we all did that day.

The fire progressed and fire engines arrived in convoys. We went home for our tea but we were anxious to get out again. And when we did, the fire was growing stronger. We watched for hours as it got worse and the flames got higher. We could see down Cheapside Street, where there was a lot of activity.

A fire engine had gone down the street and we could see it with its ladders extended high above the blaze with the hose having little impact on the fire below. There was a rumble and all of a sudden the fireman on the ladder wasn't there. A wall had come down and all we could see were clouds of dust and flames. The wall had completely engulfed the fire engine and the men in and around it. Except for the sound of burning and sudden

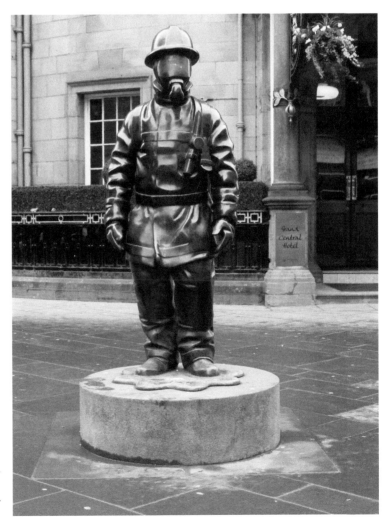

Citizen firefighter in front of Glasgow's Grand Central Hotel. (Michael Meighan)

gasps, there was complete silence. The memory of it has stayed with me ever since. It was on Monday 28 March 1960. In total, fourteen firemen, five salvage workers and three others were killed.

It is conjectured that the fire was started when highly inflammable whisky fumes came into contact with bare electric bulbs at the top of the warehouse.

In front of the Grand Central Hotel in Glasgow stands this memorial to all firefighters, past and present, of Strathclyde Fire and Rescue. I am particularly proud of this as my mother was a firewoman in the National Fire Service, a predecessor to the SFR.

When you visit the Necropolis in Glasgow you will find a memorial to those who lost their lives in the Cheapside Street Fire and who are interred there. There is also a memorial plaque on the Clydeside walkway near the scene of the fire.

The Tay Bridge Disaster

In 1848 Prince Albert bought Balmoral Castle as a Highland home for himself and Queen Victoria. Virtually overnight the idea of buying castles and hunting lodges on Highland estates became the thing for the moneyed elite. It created an enormous source of employment in estate work.

The Bank Holiday Act of 1871, as well giving paid annual holidays, created a demand for services to the seashore. The rise in commuting from the dirty city to the countryside also created passengers.

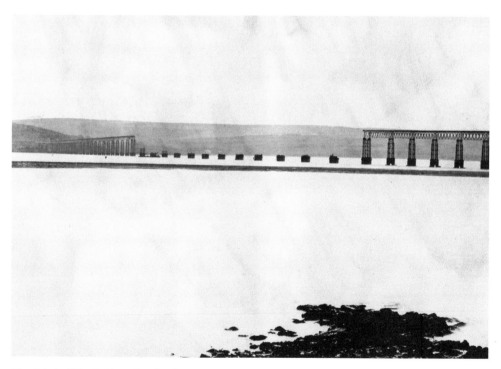

The Original Tay Bridge after the disaster.

During the nineteenth century, Aberdeen and Dundee experienced huge growth in industry and population. The jute, granite, fishing and whaling industries along the north-east coast had created a demand for quick and efficient routes to markets and factories in the south. All of this prompted the building of rail routes to the north. The companies wanted to be able to run direct routes from London to Aberdeen and Dundee.

In fierce competition with the Caledonian, North British had pushed forward with a major project to link Edinburgh with Aberdeen, building bridges over the estuaries of the Forth and Tay and over the South Esk at Montrose. These crossings were all to be designed by Thomas Bouch.

The fate of the Tay Bridge was to be instrumental in the subsequent design and building of the Forth Bridge, which, while beautiful, has always been considered to be over-engineered, but with very good reason.

Thomas Bouch was a railway engineer employed by the Edinburgh and Northern Railway where he introduced the world's first roll-on/roll-off train ferry. It was he who was responsible for the design of the ill-fated bridge over the River Tay which tragically collapsed on the night of 28 December 1879. It was a winter night of fierce gales when the six-carriage train plunged into the icy depths of the Tay carrying seventy-five passengers and crew with it.

The enquiry following the disaster shocked the world and particularly the world of engineering. It is still considered one of Great Britain's worst rail disasters and is commemorated in a poem by Dundee's William McGonagle, 'The world's worst poet'. That's possibly a bit unfair but you would have to read his other works and judge for yourself.

> Beautiful railway bridge of the silv'ry Tay
> Alas! I am very sorry to say
> That ninety lives have been taken away
> On the last Sabbath day of 1879
> Which will be remember'd for a very long time.

The enquiry found a catalogue of problems. The bridge didn't have an allowance for wind loading. The quality of castings was poor and in places flawed castings were filled with a mixture of beeswax, lamp black and metal filings called 'Beaumont's Egg'. There were also flaws in design and maintenance. What was left of the Tay Bridge was removed and a new one, designed by William Barlow, was built. The original piers survive as breakwaters.

While Thomas Bouch seems to have been critically deficient in management and leadership skills, he had nevertheless been a highly inventive engineer. Besides being responsible for the first roll on/roll off train ferry, he was also involved in developing the caisson, used since in the construction of bridge piers. His development of lattice structures was also innovative. Knighted for his work on the Tay Bridge, he was destroyed by its collapse and died not long after.

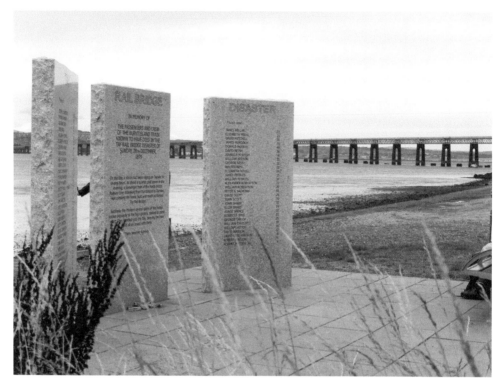

A memorial to the dead of the Tay Bridge disaster on the south shore. There is a twin memorial on the Dundee side. (Michael Meighan Collection)

8. Industrial Heritage

The Forth Railway Bridge

Bouch had also been chosen as the designer of the new Forth Bridge but inevitably his ideas were dropped. He had already submitted plans and work had been going on for around a year before the cancellation. An original pier still exists. The plans submitted for the Forth Bridge by Sir Benjamin Baker and Sir John Fowler for a cantilever bridge were accepted. The bridge builders were to be Tancred Arrol and Co.

It was to be one of the greatest engineering feats of its time and took around seven years to build the two-and-a-half-mile structure. It employed 4,600 men from Ireland, Scotland and England.

Sir William Arrol was one of Scotland's greatest engineers, responsible for many projects including the great Glasgow Central Station viaduct over the River Clyde, and Tower Bridge in London. He had founded his Dalmarnock Iron Works in Glasgow in 1871 and his own engineering company, Sir William Arrol and Co. He was knighted on completion of the Forth Bridge.

On 4 March 1890 the Prince of Wales hammered in the last of seven million rivets. It attracted worldwide attention, with the opening ceremony recorded on the front of the *Illustrated London News*.

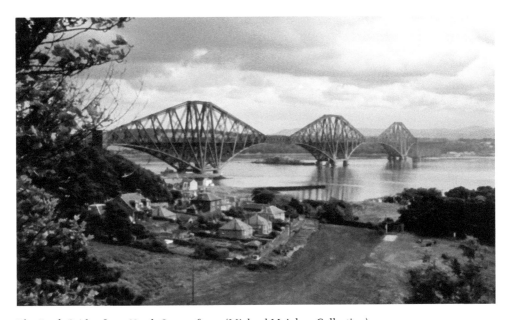

The Forth Bridge from North Queensferry. (Michael Meighan Collection)

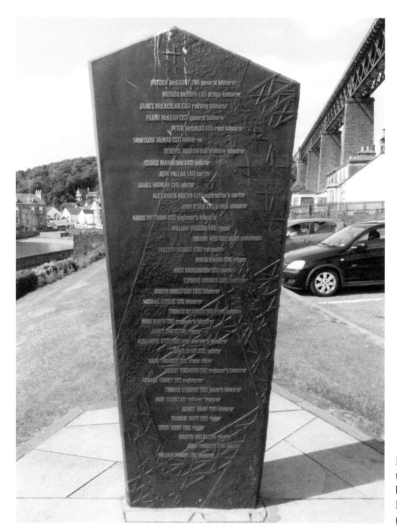

Memorial to those who died building the Forth Railway Bridge. (Michael Meighan)

While there was no disaster, fifty-seven 'briggers' (as they were called) were killed in the building of the magnificent Forth Railway Bridge. Twin memorials are on either side of the crossing.

The Kelpies, The Helix, Falkirk

The Kelpies stand as a monument to the heavy horse and its place in our industrial heritage. The beautiful beasts are at the entrance to the reopened Forth and Clyde Canal. Kelpies are mythological beasts, shape-shifting water creatures that are said to inhabit Scotland's waters. It is a great visit and if you are in the area then you can also visit the Falkirk Wheel, a rotating boat lift which, for the first time since the 1930s, joins the Union Canal to the Forth and Clyde Canal. You can travel on a boat on the Wheel.

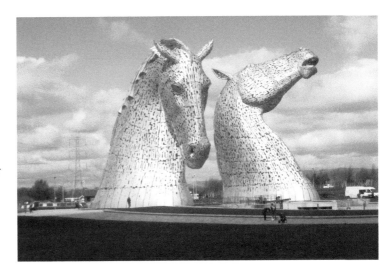

Designed by sculptor Andy Scott, The Kelpies stand at the eastern entrance to the Forth and Clyde Canal. (Michael Meighan)

The Titan Crane, Clydebank

The Titan Crane in Clydebank is one of four of this type of crane remaining on the Clyde and is a memorial to the thousands of ships launched and the thousands of workers who built them in yards all along the River Clyde. The crane was used for lifting heavy machinery such as boilers and engines onto liners and battleships.

The crane stands on the grounds of what was once the famous John Brown and Company shipyard that built some of the world's greatest ships including the *Queen Mary, Queen Elizabeth and Queen Elizabeth 2.*

This last remaining crane is a Category A listed historical structure and is now a tourist attraction and shipbuilding museum. While you are in that direction why not take a trip to the nearby Riverside Museum where you can see Glasgow's amazing collection of ship models, many of them used as models in the construction of the full-size ships.

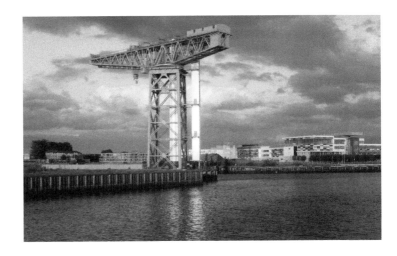

The Titan Crane, Clydebank. (Michael Meighan)

9. Politics and Public Service

Mary Barbour Memorial, Govan Cross, Glasgow

When you are in Govan visiting the Govan Stones Project or perhaps the Fairfield Heritage Centre then, at Govan Cross, you may pass a group cast in bronze. People in Govan are very proud of this new memorial to one woman whose courage and perseverance in 1915 forced the government to enact Britain's first ever rent control act.

It was during the First World War. On top of the existing poor housing conditions, Glasgow was bulging at the seams with workers drafted in for the vast armaments industry needed to feed the war. At that time there was no such thing as a council house. All rented properties were owned by private landlords who could raise rents as they liked. In Glasgow, as the war progressed and husbands were away at war, landlords raised rents whenever they could. If you couldn't pay then you could get out. There were plenty of people who would take your place.

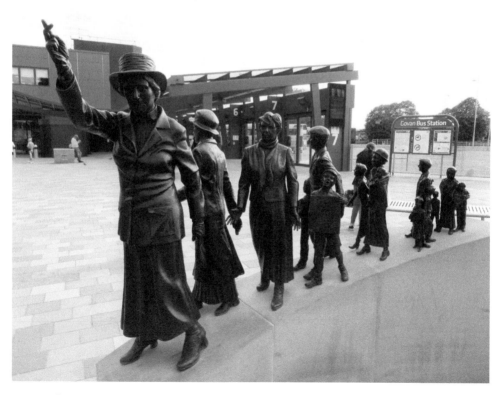

Mary Barbour memorial, Govan Cross. (Michael Meighan)

In Glasgow the landlords informed their tenants in February 1915 that all rents would be raised by 25 per cent. Many families, especially those where the breadwinner was away at war, could not possibly pay the increase and angry meetings were held all over the working-class districts of Glasgow. The idea of simply refusing to pay soon spread throughout the city and Glasgow's Labour movement gave the tenants every possible support right from the start.

Meetings were held all over Glasgow and in South Govan The Women's Housing Association was set up under the chairmanship of an 'ordinary housewife' Mrs Barbour. The association was instrumental in bringing the women of Glasgow into the fight against the landlords.

A rent strike was called and very soon 25,000 householders were refusing to pay rent. If they were being threatened with eviction by bailiffs then these were chased by the association. New renters were prevented by pickets from taking up houses of evicted tenants.

In one instance, the workers at the huge Parkhead Forge downed tools to support one family threatened with eviction. The husband was a soldier fighting in France. 5,000 turned up to prevent the eviction and the bailiffs sensibly backed off.

The government finally took notice. In November 1915, a new act was declared controlling rents. This was in no small part the work of Mary Barbour and the Housewife's Committee.

Mary was to go on to become a founder of the Women's Peace Crusade and a respected councillor in Glasgow's Town Council, one of the first women to do so.

Elsie Maud Inglis

I have particular pleasure in recording the contribution of Elsie Inglis to medicine and particularly to the hospital named in her honour in Edinburgh, for that is the hospital in which my daughter was born.

The hospital, built in 1925, replaced an original hospice opened by Elsie at No. 219 High Street. Though called a hospice, it was actually a maternity hospital run by an all-female staff. It was there for the poor in the Old Town of Edinburgh. Prior to this, Elsie Inglis' Medical Women's Club had opened a seven-bed hospital, the George Square Nursing Home, in 1899. It was in 1904 that it moved to High Street and was renamed the Hospice. In 1910 the Hospice amalgamated with Sophia Jex-Blake's Bruntsfield Hospital with whom it had cooperated for several years.

Before the First World War Elsie was a key figure in the suffragette movement, founding the Scottish Women's Suffrage Federation in 1906. However, the outbreak of war brought a time where many people wanted to make a contribution if they could not fight. The Scottish Women's Hospital was one such cause and one in which Elsie Inglis was deeply involved. Elsie met with the War Office but her suggestion of opening hospitals was turned down by HM Government. However it was subsequently accepted by the French, then by the Belgians and by Serbia.

Very soon after the outbreak of war a hospital was established at Calais to assist the Belgians. Soon after, under the auspices of the Scottish branch of the National Union of Women's Suffrage Society, she was able to establish the Scottish Women's Hospital

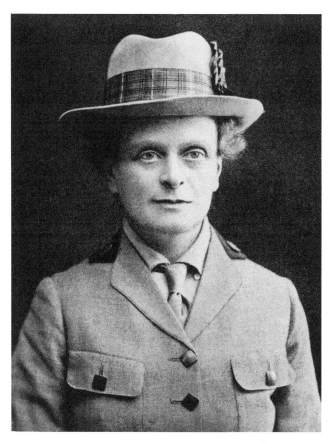

Elsie Maud Inglis.

at the Abbaye de Royaumont Hospital in 1914. The Chief Medical Officer there was Frances Ivens, Liverpool's first woman consultant. A second hospital also followed, at Villers-Cotterets, north-east of Paris, in 1917. Here, she and her staff cared for over 10,000 wounded soldiers between 1915 and 1919.

Elsie was also instrumental in sending women's units to others theatres of war including Serbia, Romania and Salonika. She served in Serbia from 1915 and it was here, while she and her team were fighting disease, that she and other members of her staff were imprisoned, and only released with the assistance of US diplomats.

On return to Great Britain she set about raising funds for a hospital in Russia and went there in 1916. However, the conditions there, as well as long hours, took their toll and she succumbed to illness in 1917. She died in November of that year, aged fifty-three.

The Elsie Inglis Memorial Hospital was incorporated into the National Health Service in 1948, along with many others. It closed in 1988. A plaque commemorating Elsie can be seen at No. 219 High Street in Edinburgh.

While Elsie Inglis was probably the most well-known medic who went to war, she was by no means the only one. Many women made a contribution. Dame Anne Louise McIlroy (1878–1968), although Irish, was one of our first women medical graduates, from Glasgow University in 1900. She was a gynaecological surgeon at Glasgow's

Elsie Maud Inglis at No. 219 High Street, Edinburgh. (Michael Meighan)

Victoria Infirmary from 1906 to 1910. As part of the Scottish Women's Hospital for Foreign Service, she was put in charge of a French military hospital at Troyes but was posted to Serbia and Salonika, and in the latter established a training school for nurses. She then completed her war service in a Royal Army Medical Corps hospital in Constantinople. Following the war she was to become Britain's first medical professor at the London School of Medicine for Women. She was a founding member of the British College of Obstetricians and Gynaecologists.

Margaret Fairlie became an emeritus professor of midwifery at St Andrews University and a founder member of the Royal College of Obstetricians and Gynaecologists. Margaret served in the Royaumont Hospital as a medical orderly. The artist Norah Neilson Gray of the Glasgow School, a 'Glasgow girl', was at Royaume where she also found time to paint. Many more brave women can be found on the Scottish Women's Hospital website.

Isabella Elder and Queen Margaret College

You may visit Govan to see the Govan Stones and while you are there you should visit Elder Park, which is a lovely green space in this area recovering from industrial dereliction. The park was given by Mrs Isabella Elder in memory of her husband John Elder who, along with Charles Randolph, established the Fairfield Shipbuilding and Engineering Co. on Fairfield Farm. John Elder was one of Scotland's greatest engineers whose major achievement besides the shipyard was the development of the compound engine that was to revolutionise ship propulsion. His designs were able to make possible fuel savings of up to 40 per cent and so compete effectively with sail. You can see his statue in Elder Park.

Isabella was a force in her own right. At her husband's death in 1869 she took control of the world's leading shipyard for seven months until it passed to a partnership managed by her brother John Ure.

She then devoted her time to philanthropic works. Elder Park and Elder Park Library were her gifts and she also set up a school of domestic economy in Govan to help

Isabella Elder, Elder Park, Govan. Look also for the memorial to *K13*, a Fairfield-built submarine lost in the Gareloch in 1917. Thirty-two men including six shipyard workers were lost. (Michael Meighan)

young women with limited income manage a household. She endowed a chair of naval architecture at Glasgow University as well as funding lectures at the West of Scotland Technical College, a forerunner of the University of Strathclyde.

Perhaps her crowning achievement was her purchase of North Park House to host the new Queen Margaret College, the first college in Scotland to provide higher education for women. This subsequently merged with the university and in 1894 the first women medical students graduated. Her statue stands in Elder Park as a tribute to another great woman working for the good of other women.

Woman and Child Memorial, Lothian Road, Edinburgh

Scottish Local Authorities have a proud background in opposing Apartheid in South Africa and Scotland was proud of the recognition it received when Nelson Mandela received the Freedom of the City of Glasgow in 1993.

This memorial, erected by the City of Edinburgh District Council, was sculpted by Ann Davidson. It was unveiled in 1986 by Suganya Chetty, a member of the African National Congress who was living in Edinburgh at the time. It represents all those killed or imprisoned for their stand against Apartheid.

Woman and Child Memorial, Lothian Road, Edinburgh. (Michael Meighan)

10. Finally – More than History

So far in this book we have travelled around Scotland visiting the many memorials and monuments associated with our history. What makes it more delightful is that the history takes place in a land so beautiful it can take your breath away.

From the soft and rolling Border lands to the wild and rugged Hebrides; from the mountainous Grampians to the Victorian splendour that is Glasgow. And from Burns Country in Ayrshire to the 'Athens of the North', Edinburgh, there is an ever-changing landscape that both enchants and delights in all four seasons.

We make much of our history but let's not forget that we also have a future. It is not so long ago that in 1999 that the Presiding Officer brought the gavel down on the first session of our modern new parliament building, in a most fitting location close to Edinburgh's Holyrood Palace at the bottom of the Royal Mile.

Scottish devolution was a key promise in the Labour government of 1997 and very quickly in a referendum in 1997 the Scottish people voted for devolution and as a consequence, the Scotland Act of 1998 and subsequent acts have given the Scottish parliament a wide range of powers.

Scottish parliament building 'Holyrood'. (Michael Meighan)

A first election was held on 6 May 1999 and on 1 July of that year powers were transferred from Westminster to the Scottish parliament, now simply called 'Holyrood'.

From September 2004 the Scottish parliament has sat in a remarkable home. The building was designed by Catalonian architect Enric Miralles along with local company RMJM. The building was opened by Queen Elizabeth II on 9 October 2004.

Our Scottish parliament is still very new and still finding its feet, but you can see how it works by visiting during a working session. The building is truly magnificent and a great complement to your visit to the Palace of Holyroodhouse.

Acknowledgements

I am grateful to those who have given me permission to take photographs or have provided images. I am particularly grateful to Govan Parish Church, Stevencdickson via Wikimedia Commons, Stirling Council via Flickr and especially to Jill for reading, editing and generally supporting me in this effort. Thanks too to Graham and Lesley for assisting with photographs in Aberdeen.

Finally, I am very grateful to the staff of Amberley Publishing who have made this and previous books possible. Thank you so much.